Courtship Quilts

Inspired by the Victorian Language of Flowers

JANNA L. SHEPPARD

Martingale®
& COMPANY

DEDICATION

For my son, Wes, who has always been my best buddy and hero. We sure have had a lot of great times together! Thanks for being such a fabulous son. I also dedicate this book to my mom, Sandra, who has been my partner in crime for many years and has supplied a lot of love, friendship, support, and great visits over a cup of tea. I love you both so very much.

ACKNOWLEDGMENTS

Thank you, Martingale & Company, and in particular Karen Soltys and Terry Martin for your help and support. I wish to thank Michael and Kari Colwell of Photo Image Center for producing some last-minute photos at Christmastime.

Printed in China
10 09 08 07 06 05 8 7 6 5 4 3 2 1

Library of Congress Cataloging-in-Publication Data
Sheppard, Janna L.
 Courtship quilts : inspired by the Victorian language of flowers / Janna L. Sheppard.
 p. cm.
 ISBN 1-56477-632-8
 1. Appliqué—Patterns. 2. Patchwork—Patterns.
 3. Quilting. 4. Flowers in art. I. Title.
 TT779.S5155 2005
 746.46'041—dc22
 2005016000

CREDITS

President: Nancy J. Martin

CEO: Daniel J. Martin

VP and General Manager: Tom Wierzbicki

Publisher: Jane Hamada

Editorial Director: Mary V. Green

Managing Editor: Tina Cook

Technical Editor: Cyndi Hershey

Copy Editor: Melissa Bryan

Design Director: Stan Green

Illustrator: Laurel Strand

Cover and Text Designer: Shelly Garrison

Photographer: Brent Kane

MISSION STATEMENT
Dedicated to providing quality products and service to inspire creativity.

Contents

Introduction

I've always liked stately Victorian homes and the formal gardens that surround them. As a quilter and student of vintage quilts, I've admired the floral appliqué on antique quilts and wished I knew what some of those flowers were and why their motifs were added to the quilts. In every historical reference I looked through, I found nearly every topic you can imagine except ones that could help identify the more unusual floral appliqué motifs and tell me what purpose they served in the quilts. After all, botany was everywhere in the nineteenth century, so if it was such an important part of life, where were the answers?

The moment I started accumulating a collection of antique Language of Flower books, I fell head over heels in love with this romantic language. My search for the various plants within the floral dictionaries led me through an archaeological dig into the mind-set of kings and commoners. I found the wildest historical connections, linking topics such as courtship and romance, fairies, royal lineage, murder, love potions, and modern medicine, just to name a few, and I learned that botany has influenced every aspect of life for thousands of years!

Victorian quilters may have added floral appliqué to their work simply because those plants were vital to daily life. But I'm happy to have discovered much of the history and symbolism of these beautiful blooms and to have appliquéd secret messages into my quilts using one of Cupid's courtship tools, the language of flowers. Once you know that the rose symbolizes "grace and beauty," or that a dahlia means "I think of you constantly," or that cosmos is the reflection of "a rejoicing heart," imagine the fun you can have combining beautiful appliqué with a secret message for the recipient of the quilt!

Courtship Quilts converts this language into appliqué and adds historical borders to the quilts that are fun, fresh, and exciting to make. Each project uses fast appliqué and strip-piecing techniques with every skill level in mind. In the section "Patchwork and Pressing," there are tips for making perfect bias strips, blocking ideas to keep quilts in shape, and easy strategies that help with sewing pieced borders to quilt tops.

I hope you enjoy *Courtship Quilts* and use the elements from this book for many other projects to come. The floral appliqué featured here offers several ways to be more expressive in your creative process, using designs that are fresh and unique to the art form of quilting. I love the pieced borders—they work like a beautiful necklace, adding sparkle, movement, and interest, while being easy and novel! Can life get any better than this?

Fabric Selection

All the projects in this book have been made with 100%-cotton fabrics. With the exception of fabric that is hand-dyed, red, or very dark, I don't prewash fabric, because I like the antique look that slight shrinking gives the quilts after they're made and laundered.

Color and Pattern

You may be surprised to learn that the nineteenth-century color palette wasn't always dark and restrictive. During the early 1800s, subtle pastels were popular for home interiors, decorative arts, and fashion, and the patterns that highlighted them were Greek, Egyptian, and Roman motifs, in addition to the time-honored English and French florals. As the century wore on, the colors and moods darkened to the somber palette we normally associate with the entire Victorian era, and floral and Japanese themes were popular. For a society that imposed rules upon nearly every aspect of life, they had none to guide them through color and pattern. Today, we have color wheels and value finders to help us in our choices, but back then they simply chose what they liked, adding color and pattern until a certain space had an organized chaos of many cultures and hues.

The fabrics that I selected for the projects in this book lean more to the early nineteenth-century palette, influenced by my personal preferences and including a wide variety of patterns. When choosing fabrics for a particular project, I always buy with the following ideas in mind:

- Use the most vibrantly colored fabrics for the appliqué blocks and space them randomly so that the eye will want to move over the entire area of the quilt.

- Whenever possible, add fabrics with cultural motifs that complement and enhance the other fabrics or the theme of the quilt.

- Add as many print scales as possible. Use large-, medium-, and small-scale patterns, in addition to geometric and flowing styles.

- To create a sparkling quilt, use variety in the pattern, scale, and color of the background fabrics. By echoing the main fabric colors, you generate secondary interest. In choosing background fabric for "True Love" on page 36, I used very faintly colored fabrics ranging from pale yellow to gray to green, blue, and white that mirror the appliqué colors.

- Once you've chosen a few initial colors for your quilt, branch out and add warmer, cooler, brighter, lighter, or darker colors as accents.

- Just because a certain fabric isn't within the body of the quilt doesn't mean you can't use it in the border. If the fabric fits, go ahead and use it.

- Pieced borders are like jewelry for a quilt, adding sparkle, interest, and movement. When selecting fabric, keep in mind that your appliqué is the star of your quilt and the pieced border takes second stage. Try a medium-intensity color that coordinates with the quilt. The scale should ideally be medium or small so that the pattern doesn't get lost.

- Fabrics can look different when cut into small pieces. Before deciding to use a fabric, cut a sample, step back, and look at it awhile.

Tools and Supplies

This section lists the basic items that you'll find helpful for completing the projects in this book.

Cutting tools and rulers: You'll need a large cutting mat, a rotary cutter, a small pair of scissors with a sharp point, and paper or craft scissors for cutting out templates. You'll also need clear acrylic rulers in 6" x 6", 6" x 24", and 16" x 16" sizes.

Pressing tools: You'll need an ironing board, preferably covered with muslin for blocking patchwork into shape; a steam iron; a can of spray starch; an old towel for pressing appliqué so that it won't flatten too much when pressed; and a pressing cloth. Believe it or not, I prefer to use copy paper for pressing bias stems because it allows me to get them very flat. A nonstick pressing sheet is great to have if you do a lot of fusible-web appliqué. Also, a small wooden pressing iron can be helpful when working with interfaced appliqué shapes.

Marking tools: Use a permanent fine-tip marker for making templates. A quilter's mechanical pencil with very fine lead and a water-soluble marker are both effective for making temporary marks on fabric. A permanent marker with a very fine tip in sepia or gray is nice to use when writing within poetry (blank) blocks.

Pins and needles: I prefer several types of pins—extra-long pins with a flat, metal head, extra-long pins with glass heads, and extra-fine silk pins, which work best. For piecing and appliqué, machine needles in sizes 70/10, 75/11, and 80/12 all work well. For machine quilting, sizes 80/12 and 90/14 provide good results. If you want to quilt by hand, start with a size 8 Between needle and adjust as you become more comfortable with the process. Embroidery needles will be needed for adding any embroidery accents to the quilts.

Appliqué stabilizers, glues, and fusible web: Lightweight, nonwoven fusible interfacing is used in the interfacing method of appliqué. For some of the other projects, you'll need paper-backed fusible web. Be sure to buy "light" fusible web, which has a lighter coating of adhesive and allows for easier machine appliqué. Paper-backed fusible-web tape in the ¼" (5 mm) width is used in most of the projects to adhere flower stems and basket handles.

Template plastic: Use clear plastic to make most templates, but for circles it's best to use No-Melt Mylar. This is a heat-resistant product used in much the same way as template plastic, with the difference that it can withstand ironing.

Other tools: A point turner is very helpful when turning interfaced shapes right side out. A stiletto is nice for pulling out any stubborn tiny areas, as well as for helping to guide the fabric under the presser foot when sewing. For making stems, you'll need ¼", ⅜", and ½" bias press bars.

The following guidelines are designed to help you construct your quilt with accuracy and a minimum of frustration.

Seam Allowances

Whether you're piecing a block or assembling a quilt, it's important to sew with a consistent seam allowance that gives you accurate final measurements. It's not enough to simply say that you must sew a ¼" seam, because achieving an *accurate* ¼" seam allowance is the issue. For example, if two strips are sewn with a seam allowance that is supposedly ¼", the sewn and pressed piece could easily measure ¹⁄₁₆" to ⅛" off from what it's supposed to be. Add up those discrepancies in an entire quilt and you can be off by quite a few inches. Experiment with seam guides, needle positions, or ¼" presser feet that will help you achieve the best result.

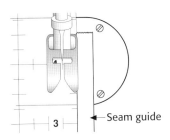

Seam guide

3

Pressing

In this section, you'll find tips for pressing straight-cut strips as well as pieced and appliquéd blocks. Instructions on pressing bias and straight-grain stems as well as appliqué motifs are covered in "Appliqué" on page 9.

BLOCKING

Pressing adds shape to blocks and quilts. You need to be sure that the shape is the one you want! Everything that's placed under an iron is *blocked*, whether or not you realize it. Blocking refers to the fact that heat softens a natural fiber and allows the fiber to be reset into a specific shape when the fabric cools. If you're not careful when you press, your strips, blocks, and quilts may become skewed. Keeping that in mind, it's easiest to block intentionally throughout the entire quilt process. Then your strips, blocks, and quilts will take on a higher quality of workmanship.

MUSLIN IRONING-BOARD COVER

Of all the types of ironing-board covers, muslin works the best because it grabs and holds quilting cotton. To make an ironing board cover, gather the following materials:

- 2¼ yards of 45"-wide medium-grade muslin
- 2 layers of medium-weight cotton batting for padding
- Needle with very large eye
- Heavy cotton string

1. Wash and dry the muslin completely and refold it the way it came off the bolt.

2. Place the ironing board upside down on the batting and trace the shape of the board onto the batting. Cut out the two layers of batting.

3. On a flat surface, center the batting over the muslin and then place the ironing board top onto the batting.

4. Thread the needle with about 36" of heavy string and knot one end. Fold the excess muslin to the underside of the board and starting at the center of the board, use the needle and string to lace the muslin edges together as if you were lacing a shoe. Continue lacing and pulling the muslin taut until you have worked your way around the entire ironing board. Restring the needle as necessary.

5. Turn the ironing board upright. Using a 6" x 24" clear ruler and a fine-point permanent marker, draw straight lines across the width and length of the board to use for blocking your completed quilt blocks. Align the ruler with the straight edge of the board and use the marker to draw a line along the edge of the ruler.

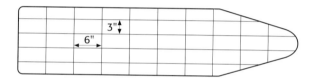

6. Set the marked lines using a dry iron on the cotton setting. This will prevent spray starch from causing the lines to blur.

PRESSING STRIPS

Narrow strips, those 2" wide or less, tend to distort more easily than wider strips. After sewing those strips to other strips or to the quilt, always block the strips flat and straight. With wrong side of the strip facing up, line up the side of a strip with a straight line on the ironing board, making sure each end of the strip is straight as well, and pin each end in place. Finger-press seams either open or to one side according to the project instructions or your personal preference. Spray the strip *lightly* with spray starch. Allow the starch to penetrate the fabric, and then iron the strip dry, keeping seams either open or pressed to one side. Pressing strips in this manner ensures that they will be blocked straight and prevents further stretching.

PRESSING BLOCKS

All blocks should be blocked flat and straight *before* pressing seams. Place the edge of a block or row of blocks even with a straight line on the ironing board, making sure all sides of the block are straight as well. Apply starch, allow to dry, and finger-press the seam allowance to one side before pressing the seam flat.

Making Templates

You'll need to make templates for *each* appliqué shape by placing the plastic over the pattern and tracing with a fine-tip permanent marker. Cut out the templates directly on the marked line, without adding any seam allowances. Any wobbly cuts can be smoothed out with an emery board.

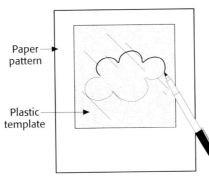

Paper pattern

Plastic template

When making a template for a basket and handle, trace the lines of the basket and handle shapes and then mark the centering lines. Cut out the basket and handle as one unit, around the outside only. Separate the basket from the handle by cutting along the top of the basket.

Fusible Appliqué

1. For a symmetrical shape, place the template on the paper side of the fusible web and trace the design.

 For an asymmetrical shape, you need to trace the *reverse* of the shape. Reverse the direction of the template before you trace the design. Note that if there are many pieces to

a design, you should carefully label each template. Trace all required pieces, leaving approximately ¼" between each piece.

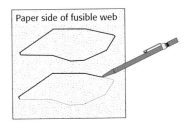

Paper side of fusible web

2. Cut the pieces apart to separate them, but don't cut on the line yet. Place each piece on the wrong side of the fabric. Fuse, following the manufacturer's directions. Let the appliqué cool, and then cut out each shape on the drawn line. Peel off the paper and position the shapes, right side up, on the background fabric. Fuse again, following the manufacturer's directions.

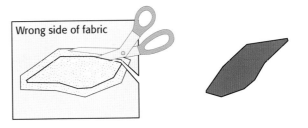

Wrong side of fabric

To construct a single flower from several appliqué shapes, it's easiest to assemble the shapes as a unit first and then place the flower on the background fabric. To do so, place an appliqué press sheet over the appliqué pattern for the flower. You'll be able to see the illustration through the press sheet. Peel off the paper backing from the fusible web and arrange the appliqué pieces on the press sheet, following the diagram. The patterns are numbered in the order they are appliquéd. Fuse each piece one by one to the press sheet until the flower is complete. Let cool, and then pick up the fused unit. It won't stick permanently to the press sheet. Then place the fused appliqué unit on the background

fabric, fuse, and stitch the appliqué edges using your preferred appliqué stitch.

Interfacing Method of Appliqué

1. Place the templates on the nonadhesive side of lightweight, nonwoven fusible interfacing and trace. Cut apart the pieces, leaving at least ½" between each shape. Don't cut on the line.

2. Pin the interfacing shapes so that the adhesive side is against the right side of the fabric. Sew on the line with the machine stitch set at 18 to 20 stitches per inch. Cut out the shapes, leaving a scant ¼" seam allowance.

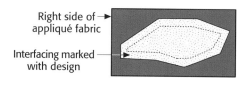

Right side of appliqué fabric

Interfacing marked with design

3. Carefully cut a small slit through the interfacing only and turn the shape right side out, using a point turner where necessary to get sharp points and edges. When the entire appliqué piece has been turned and all the edges have been smoothed out, arrange the appliqué on the background fabric and fuse in place following the manufacturer's directions. Stitch the appliqué in place using your preferred appliqué stitch.

Perfect Fabric Circles

1. Trace the circle pattern onto No-Melt Mylar and then cut it out on the line. Sand any uneven edges with an emery board.

2. Cut out the circle of fabric approximately ¼" larger all around than the traced shape.

3. Double thread a needle, make a knot, and sew even running stitches ¹⁄₁₆" to ⅛" from the cut edge of the circle until you reach the starting point. Place the circle of Mylar in the center and pull the threads until the fabric gathers closely around the circle.

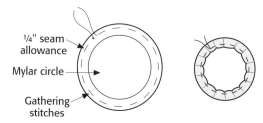

¼" seam allowance

Mylar circle

Gathering stitches

4. Spray the fabric with starch and allow it to soak into the fabric. Keeping the threads tightly drawn, cover with a sheet of clean copy paper or a press cloth and iron without steam until dry. Gently pull the plastic circle out and tug on the thread to reshape.

Bias and Straight-Grain Strips

The stems and basket handles in this book use ¼", ⅜", and ½" bias press bars. They come in either metal or heat-resistant plastic and are available in most quilt shops.

1. If necessary to achieve the desired length, join bias or straight-grain strips together end to end and press seams open. Each project specifics the size of the strips as well as the size of the bias press bars that will be needed. Bias strips are used when the stem or handle will be shaped into curves. Straight-grain strips are used where the finished stem or handle is straight.

2. Fold the strip in half lengthwise, wrong sides together, and sew with a *scant* ¼" seam to make a tube. If using a ¼" or ⅜" bias press bar, you'll need to trim this seam allowance to ⅛" so that it won't show under the finished stem or handle. Insert the bias press bar into the tube and position the seam

allowance under the bar so that it doesn't show. Press the tube flat with the seam allowance pushed to one side. Carefully push the bar through the tube to the opposite end. Be aware that the metal bars can get very hot!

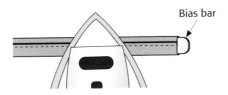

Bias bar

3. Remove the bar and iron ¼" paper-backed fusible-web tape to the wrong side of the tube, following the manufacturer's directions. Cut the pressed tube into the lengths required for your project. It's usually easiest to lay the pressed tube—commonly called tape—over the placement line of the design to determine how long to cut each piece of stem or basket handle.

Fusible-web tape

4. Remove the paper strip from the fusible-web tape and position the tape against the traced line on the background fabric. Fuse in place and appliqué both edges using your preferred appliqué stitch.

CURVED STEMS AND HANDLES FROM BIAS TAPE

Pressing bias tape into curves is easy. Using a quilter's mechanical pencil, lightly trace the curved line of the placement template onto the background fabric. Place the fabric on the ironing board and use flat-head pins to fasten the edge of the bias tape flush with the drawn line every ¼" to ½". Set the iron on steam and press the tape by lifting and moving the iron (not dragging) along each section of tape. Remove only one pin at a time so that the bias tape doesn't move out of place.

Background fabric

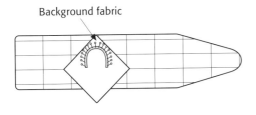

When sewing curved sections of bias tape, it's easiest to sew the inside curves first and then the outside curves.

SHARP POINTS FROM BIAS TAPE

Using the appliqué template, trace the line onto the background fabric. Position the outer edge of the tape against the traced line and pin every ¼" to ½" until you reach the point or corner. Swing the tape around until the outer edge lines up with the line again and forms a fold at the corner. Push the fold under the corner and pin in place. Continue to pin along the remainder of the tape.

Set the iron on steam and press the tape, removing only one pin at a time so that the tape doesn't move out of place.

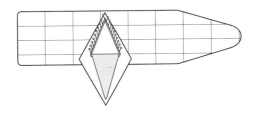

Stitching Appliqué Shapes by Machine

For all of the appliqué shown in this book, I used a machine blanket stitch. However, you could also use a blind stitch or a satin (zigzag) stitch.

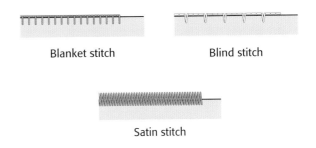

Blanket stitch

Blind stitch

Satin stitch

Stitching Appliqué Shapes by Hand

1. Using thread that matches the color of the appliqué fabric, thread your needle with a length about 18" to 24" long. Knot one end of the thread.

2. Bring the needle up from the wrong side of the background fabric and through the folded edge of the appliqué. Try to make this stitch as close to the edge of the appliqué shape as possible.

3. Insert the needle back into the background fabric, about $\frac{1}{16}$" from where it came up. The needle should be inserted slightly underneath the folded edge of the appliqué shape to hide the stitch. Continue making stitches in this manner, making them taut enough so that they are invisible, but not so tight that they pucker the appliqué.

4. To end the stitching, bring the needle to the wrong side of the background fabric and take a small stitch, pulling until a small loop remains. Take the needle through the loop several times and then pull completely to form a knot. Bury the tail of the thread between the layers of fabric along the edge of the appliqué to hide it and snip the remaining thread.

Pressing Appliquéd Blocks

Keep a clean towel stored next to the ironing board for pressing appliquéd blocks. When the appliquéd block is complete, give it a final press. Open the towel and place it on the ironing board, then place the block over the towel with the right side down and gently press with steam to remove all the wrinkles. Square the appliqué block to the correct size using a ruler and rotary cutter.

Embroidery

Some of the projects in this book include embroidery. I used several different embroidery stitches, with either two or three strands of embroidery floss for each type of stitch. You can also use one strand of size 8 pearl cotton. Use an embroidery needle with either thread.

Backstitch

Feather stitch

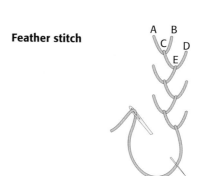

Bring the needle up at A, then down at B, forming a U shape. Bring the needle back up at C to form the "catch," then down at D, once again forming a U shape.

French knot

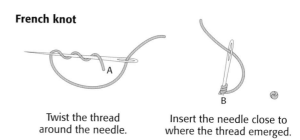

Twist the thread around the needle.

Insert the needle close to where the thread emerged.

Running stitch

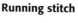

Satin stitch

The stitches are worked side by side, just touching.

Stem stitch

Each project uses one of three block settings. Straight rows are used in "The Gathering" on page 85. Diagonal rows are used in "Affection's Offering" on page 44. Vertical block (strip) sections are used in "Love's Labyrinth" on page 18. For each project, look to the project directions for an assembly diagram. Before the blocks of any quilt are sewn together, it's always important to check that they are the desired size. Using a ruler, measure all four sides of each block, trimming away any excess fabric that extends beyond the seam allowance.

Straight-Set Blocks

Arrange the blocks so that color is evenly spaced across the quilt. Sometimes it's hard to recognize awkward arrangements when you're close to the blocks, which is why a design wall comes in handy. Placing your blocks on a design wall makes it easier to step back and take notice of those areas that need changing.

1. Place the blocks in a side-by-side fashion, inserting sashing if applicable. Mark the blocks so that you'll know the sewing order and avoid getting something out of place.

2. Sew the blocks in each row together, blocking each seam as it's sewn and making sure all the edges are even. Press the seam allowances in one direction and alternate the direction from row to row. The seams will then oppose each other, making it easier to sew the rows together. If you have sashing with cornerstones, sew the sashing rows together and press in the same manner as for the blocks.

3. Pin two rows together at a time, making sure the seams of each block intersection match up

exactly. Sew the rows together, blocking carefully as you complete each seam. Continue joining rows into pairs, and then sew the pairs together until the quilt body is complete.

Vertical Block (Strip) Sections

The instructions for quilts with this setting are specified within each applicable project. Generally, this setting combines the techniques from the previous two settings—straight-set and diagonal.

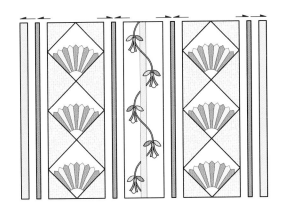

Diagonally Set Blocks

In a diagonal block setting, side and corner setting triangles are placed along the outside edges to create a square or rectangular quilt top.

1. Arrange the blocks and setting triangles in diagonal rows, in a visually pleasing manner, with each block set on point. Mark the blocks so that you'll know the sewing order and avoid getting something out of place.

2. Sew the blocks and side triangles in each row together, blocking each seam as it's sewn and making sure all the edges are even. Press the

seam allowances between blocks in one direction and alternate the direction from row to row. The seams will then oppose each other, making it easier to sew the rows together. Press the outer seams toward the side triangles.

If you have sashing with cornerstones, sew the sashing rows together and press in the same manner as for the blocks.

3. Pin two rows together at a time, making sure the seams of each block intersection match up exactly. Sew the rows together, blocking carefully as you complete each seam. Continue joining rows into pairs, and then sew the pairs together until the quilt body is complete. Attach the corner triangles after you've joined all the rows, pressing toward the triangles.

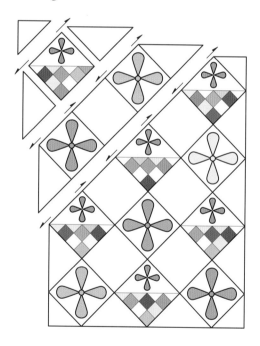

4. Using a 6" x 24" ruler and rotary cutter, trim along the sides of the quilt to remove any fabric that is over the ¼" seam allowance.

Adding Borders

There are usually several borders for each quilt in this book and at least one of them is pieced. Surrounding the pieced border are narrow border strips. These serve two functions. They act as design elements to help the eye make the transition from one pattern to another. They also are used to make the quilt top the size it needs to be for the pieced border to fit correctly. For this reason, you may see that some of the narrow borders are different sizes on the top and bottom compared to the sides of the quilt. The project directions specify the sizes of each border strip.

To sew border strips to the quilt, fold the edge of the quilt top into quarters and mark those points at the outer edges. Fold the border strips in quarters as well and mark. Match the marks on the border strips to the marks on the edge of the quilt top and pin. In addition, match the cut ends of the quilt top and borders, and pin in place. Next, place several pins between each of these five pins. Block the seam with steam and press the seam to one side as specified in the project instructions.

Adding a pieced border section to a quilt body is easy if, instead of using an iron to press the pieced border initially, you finger-press the seam allowances in the border. This way, you can block any *slight* size discrepancies in the pieced border so that it will fit the quilt.

Fold and mark the pieced border strips and quilt top as described above. Pin the border sections in place, matching the marks on the border to the marks on the edge of the quilt. Match the cut ends of the border strips and the quilt as well, and pin in place. With the iron set on steam, block the pinned border in place, making sure to press the seam allowances in the correct direction.

Finishing

Once your quilt top is complete, there are some important considerations to keep in mind when getting ready to finish your quilt. Because the quilting adds the final personality, you'll want to determine the batting type, quilting style, and binding fabric. Choose these elements carefully, as each one greatly influences the look of your finished project.

Assembling the Layers

For the projects in this book, the quilt backing and batting measurements are 6" larger than the quilt top. Larger quilts will need to have a backing that is sewn together in sections with seams pressed open. You can also purchase extra-wide fabric if you prefer not to piece the quilt backing, but keep in mind that you'll still need the backing to be 6" larger than the quilt top.

1. Fold the backing in half each direction and mark the edges. Spread it out on a flat surface with the wrong side up and use masking tape to secure it in place.

2. Place the batting over the backing, centering it and smoothing out any ripples.

3. Fold the quilt top in half each direction and mark with a pin. Then, line up the pins on the quilt top with the centering marks on the quilt backing. Pin all three layers together at the centers and corners.

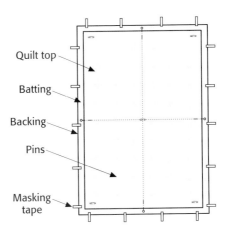

4. If you're going to hand quilt, start from the center of the quilt top and baste with light-colored thread through all three layers, extending your stitches diagonally in both directions. Then baste across the quilt every 5" both vertically and horizontally to form a straight grid. Finally, run a line of basting stitches around the outside edge of the quilt to prevent stretching.

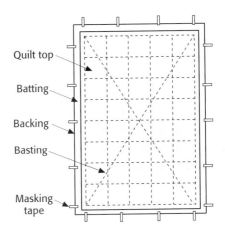

15

5. If you're going to machine quilt, use safety pins to baste, placing them every 5" or so.

Getting Ready to Quilt

The Victorian mind-set believed every open space should be filled with design. Quilting is a finishing design element that fills any empty spaces and provides the quilt with its final personality. As a result, it makes Victorian sense to add as many different patterns in the quilting as possible. Try to vary the pattern, from geometric to floral, and space the quilting as evenly across the quilt as possible. To highlight certain areas and delineate sections, in-the-ditch and outline stitching will make areas pop out. Once you have planned your quilting strategy, mark the quilt top. Choose a marking tool that can easily be removed, and test it ahead of time on scrap fabric to make sure the marks will come out of the quilt.

Quilting

Whether you quilt by hand or machine, stabilize your blocks and promote straighter lines by first quilting along the edges of all blocks and borders. Next, add additional quilting and details to reflect your special personality. For hand quilting, a quilt hoop will help support the quilt

and enhance your comfort level if you plan to quilt for an extended period of time. *The Quilter's Quick Reference Guide* by Candace Eisner Strick (Martingale & Company, 2004) is a good source for detailed instructions on hand quilting.

If you're going to quilt by machine, you'll need a walking foot for straight lines and gentle curves. The foot will help keep the layers from shifting. The use of a darning foot or a spring-needle will help with free-form and stipple quilting. A cotton batting with a low loft will give you the best results. Refer to *Machine Quilting Made Easy!* by Maurine Noble (Martingale & Company, 1994) for detailed instructions on machine quilting.

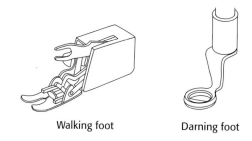

Walking foot Darning foot

Binding

1. With right sides together, sew the binding strips end to end using a diagonal seam and a short stitch, 18 to 20 stitches per inch. To make the diagonal seam, place the two strip ends at right angles and pin. Draw a line across the top strip at the angle shown, intersecting the edges. Stitch along the line.

2. Trim the seams to ¼" and press them open. With wrong sides together, press the strip in half lengthwise.

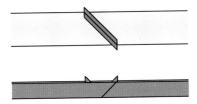

3. Beginning along one side of the quilt top, not at a corner, start sewing the binding to the quilt. Start stitching at least 3" from the end of the binding, and sew ¼" from the cut edge.

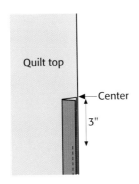

4. Stop sewing ¼" from the corner. Pivot the quilt and stitch diagonally off the edge of the quilt.

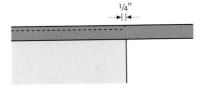

5. Pull the quilt away from the machine. Fold the binding up so that the cut edge is parallel to the next edge of the quilt. Fold the binding back over itself so that the fold of the binding lines up with the edge of the quilt.

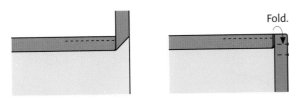

6. Continue stitching the binding to the quilt, mitering all the corners. Stop sewing within about 10" from where you started. Cut the beginning end of the binding at an angle, turn in ¼", and press. Insert the other end, trimming off any extra binding. Sew the remainder of the binding to the quilt.

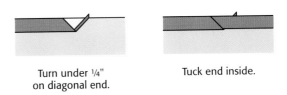

Turn under ¼" on diagonal end. Tuck end inside.

7. Press the binding away from the front of the quilt and fold it over to the back. A folded miter will be created at each corner on the front of the quilt.

8. Sew the folded edge to the back by hand, using the traditional appliqué stitch described in "Stitching Appliqué Shapes by Hand" on page 11. When you arrive at the place where the two binding ends meet, stitch the opening closed.

Love's Labyrinth

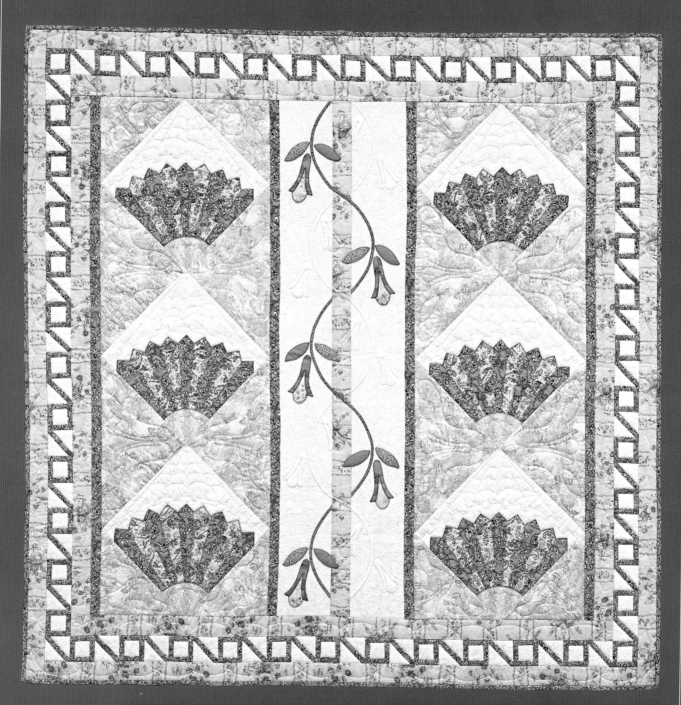

Finished Quilt: 70½" x 70½"

Finished Fan Block: 13" x 13"

Finished Canterbury Tile Border Block: 2½" x 2½"

The Chilean bellflower obtained its significance from its twining vine, which creates a maze, or labyrinth, of flowers. In Victorian times this flower was rare to find, even among those who dabbled in exotic greenhouse plants. The sentiment of this flower was considered very special and it was used on only the rarest of occasions.

Materials

Yardage is based on 42"-wide fabric.

2¾ yards of cream fabric for background of fan blocks, pieced borders, and center appliqué panels

2⅛ yards of yellow-gold fabric for center panel and borders

2⅛ yards of blue fabric for fan blades, pieced borders, vertical sashing, and binding

1 yard of light blue toile fabric for corner and side setting triangles

⅝ yard of aqua fabric for fan blades

½ yard of green fabric for bias stems

⅛ yard of light yellow-gold fabric for fan centers

⅛ yard *total* of assorted blue fabrics for flower appliqués

⅛ yard *total* of assorted green fabrics for leaf appliqués

4¼ yards of fabric for backing

73" x 73" piece of batting

Template plastic

Paper-backed fusible web

¼" bias press bar

¼" paper-backed fusible-web tape

Cutting

All strips are cut across the width of the fabric unless indicated otherwise.

From the green fabric, cut:
Approximately 60" of 1"-wide bias strips

From the lengthwise grain of the cream fabric, cut:
2 strips, 6" x 55⅝"

From the crosswise grain (width) of the cream fabric, cut:
4 squares, 13½" x 13½"

3 strips, 2" x 42"

From the remaining width of the cream fabric, cut:
2 squares, 21" x 21"

2 squares, 13½" x 13½"

From the lengthwise grain of the yellow-gold fabric, cut:
1 strip, 2½" x 55⅝"

2 strips, 3" x 55⅝"

2 strips, 3" x 60½"

2 strips, 3" x 65½"

2 strips, 3" x 70½"

From the blue fabric, cut:

2 strips, 8¾" x 42"

19 strips, 1" x 42"

6 strips, 1⅞" x 42"

8 strips, 2½" x 42"

From the aqua fabric, cut:

2 strips, 8¾" x 42"

From the light blue toile fabric, cut:

4 squares, 10" x 10"; cut once diagonally to yield 8 corner setting triangles

2 squares, 19⅝" x 19⅝"; cut twice diagonally to yield 8 side setting triangles

Preparing Appliqués and Appliquéing the Center Panel

Refer to "Appliqué" on page 9 as needed to complete the following steps.

1. Use the patterns on pages 24–25 to prepare and label all the templates.

2. Use the templates, fusible web, and appropriate fabrics to prepare the flowers, leaves, and fan centers.

3. Use the 1" green bias strips to make the stems.

4. Sew one 55⅝" cream strip to each side of the 2½" x 55⅝" yellow gold strip. Press seams toward the yellow-gold strip.

5. Place the stem guide template over the yellow-gold strip, aligning seam lines with the marks on the template. Trace along the panel, flipping the template from one side to the other as shown in the illustration at right.

6. Align the bias stem with the traced line and pin in place. Open seams as necessary to insert ends to begin or end a piece of stem. Stitch the openings closed, and fuse the stems in place.

7. Referring to the photo on page 18, arrange the flowers and leaves along the entire length of the center panel. Fuse the shapes in place and use your preferred appliqué stitch to appliqué the edges.

Constructing the Fan Blocks

1. Trace the fan blade template onto the 8¾" blue strips. Alternate the direction of the template as you trace it along the strips. Cut to make 30 blades. Repeat using the 8¾" aqua strips to make 24 blades.

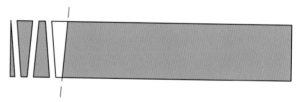

2. With right sides together, fold each fan blade in half lengthwise and lightly finger-press the fold to make a crease. At the wide end of the blade, stitch ¼" from the cut edge to the fold using a short machine-stitch length. Repeat for each fan blade. To reduce bulk, trim the seam allowance at the fold, being careful not to cut through the seam.

Trim.

Fold

3. Turn each blade right side out and match the seam line to the crease. Press.

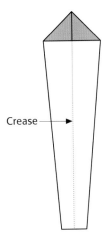

Crease

4. Arrange the fan blades as shown and stitch together. Press seams open.

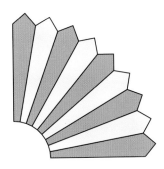

5. Pin a completed fan on a 13½" square of cream fabric. Add a fan center and fuse the center in place. Appliqué along the top edge of the fan and around the fan center using your preferred appliqué stitch. Make six blocks.

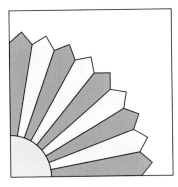

Fan block.
Make 6.

Piecing the Canterbury Tile Borders

The Canterbury Tile border consists of two block units: unit A and unit B.

1. To make unit A, begin with a 21" square of cream fabric and measure 3½" from the lower-left corner in both directions; mark. Matching the marks with a ruler, cut a 45° angle across the corner. Continue to cut 2½" strips parallel to the first cut across the entire square.

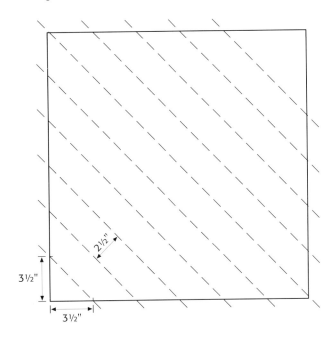

2½"

3½"

3½"

2. Without disrupting the order of the cream pieces, sew a 1" blue strip between each bias piece, keeping the bias edge on the bottom as you stitch. After the blue strips have been sewn on both sides, trim their ends even with the cream square. Carefully press the seams toward the blue strips. Repeat steps 1 and 2 using the remaining 21" square of cream fabric.

3. Use the 3" square-up template for unit A. Position the template on a strip set so that the opposite diagonal corners are centered over a blue strip. Trace. Continue to trace and cut 3" squares for unit A. Make 50. If you're comfortable using a square ruler with a diagonal line and a rotary cutter, you may find those tools to be a good alternative to using a template.

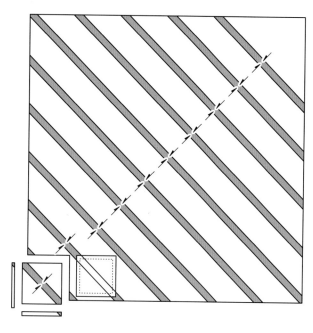

Unit A.
Cut 50.

4. To make unit B, sew a 1" strip of blue fabric to each side of a 2" strip of cream fabric. Press seams toward the blue. Make three. Crosscut the strip sets into 2" segments. Make 50.

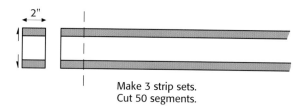

Make 3 strip sets.
Cut 50 segments.

5. Place each segment from step 4 on top of a 1" blue strip and stitch one right after another, leaving a small gap between each segment. Cut the segments apart and stitch the remaining side to a 1" blue strip.

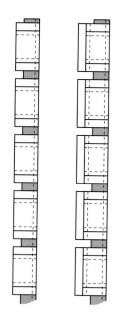

6. Cut these units apart and press seams toward the blue strips. Trim the ends, making sure that the units are 3" square. Make 50.

Unit B.
Make 50.

7. Make the Canterbury Tile border for the top and bottom of the quilt by arranging 12 of unit A and 12 of unit B as shown. Make certain that every A unit is oriented in the same direction. Sew the units together. Press seams toward the B units. Make two.

Top/bottom Canterbury Tile border.
Make 2.

Note: Although the quilt shown has fewer border units, we've modified the cutting directions to make them easier to work with. This requires more units.

8. Make the left and right side borders by arranging 13 of unit A and 13 of unit B. Make certain that every A unit is oriented in the same direction. Sew the units together. Press seams toward the B units. Make two.

Side Canterbury Tile border.
Make 2.

Assembling the Quilt Top

1. Arrange three Fan blocks with side and corner setting triangles. Sew the blocks and triangles into diagonal rows, and then sew the rows together. Press the seams toward the setting triangles. Make two panels.

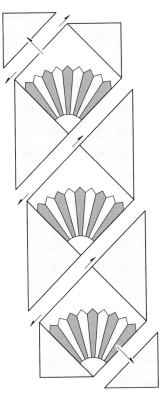

Fan panel.
Make 2.

2. Sew the 1⅞" blue strips together end to end and press. From the long strip, cut four 55⅝"-long vertical sashing strips.

3. Stitch 3" x 55⅝" yellow-gold strips, 1⅞" x 55⅝" blue strips, and the assembled

panels together as shown, sewing from left to right. Press all seams away from the panels.

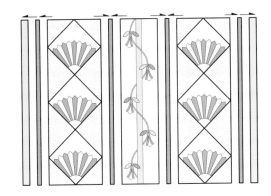

4. Sew a 3" x 60½" yellow-gold strip to the top and bottom of the quilt. Press seams toward the strips.

5. Sew the top and bottom Canterbury Tile borders to the quilt. Press seams toward the yellow-gold strips. Sew the side Canterbury Tile borders to the quilt. Press.

6. Sew the 3" x 65½" yellow-gold strips to the top and bottom of the quilt. Press seams toward the strips. Sew the 3" x 70½" yellow-gold strips to the sides of the quilt. Press.

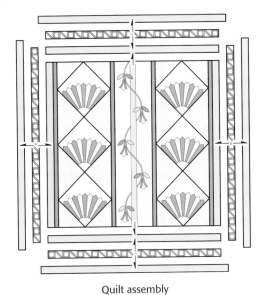

Quilt assembly

Finishing the Quilt

Refer to "Finishing" on page 15 to layer, quilt, and bind your quilt.

Victorian Flower

Chilean Bellflower

Sentiment

"I Am Lost in Love's Labyrinth"

Time was a precious ingredient in Victorian courtship. Gentlemen callers always arranged visitations in advance. However, time alone with the girl was hard to come by because parents and siblings were always around. Men were advised to "make a business of courting" and so, rather than waste time waiting for a moment alone, many men quickly advanced the relationship through the use of tussie mussies, bouquets in which the flowers selected could be decoded and cherished in private.

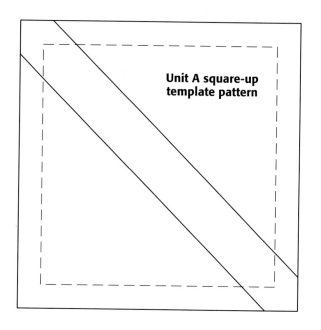

Unit A square-up template pattern

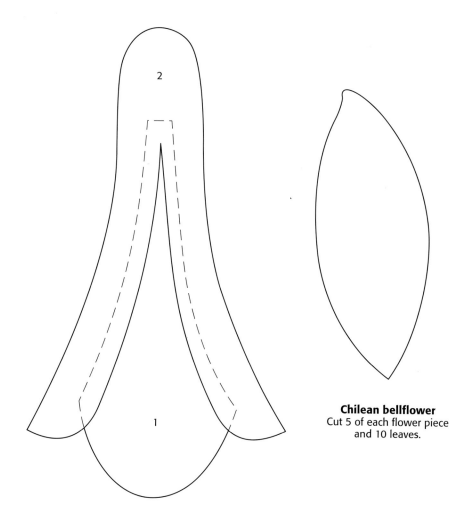

Chilean bellflower
Cut 5 of each flower piece
and 10 leaves.

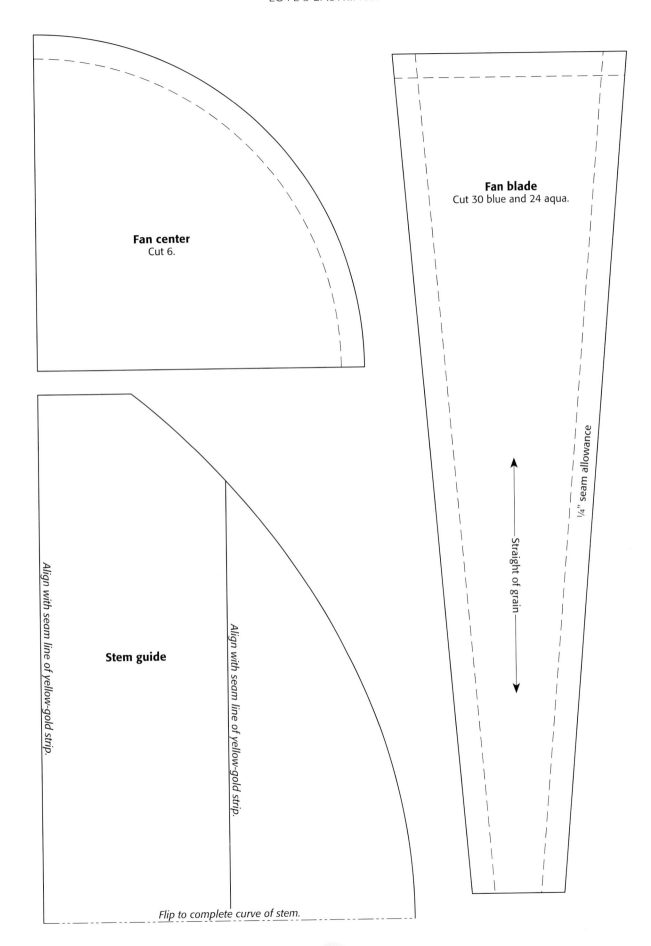

Fan center
Cut 6.

Fan blade
Cut 30 blue and 24 aqua.

¼" seam allowance

Straight of grain

Align with seam line of yellow-gold strip.

Align with seam line of yellow-gold strip.

Stem guide

Flip to complete curve of stem.

Secret Tryst

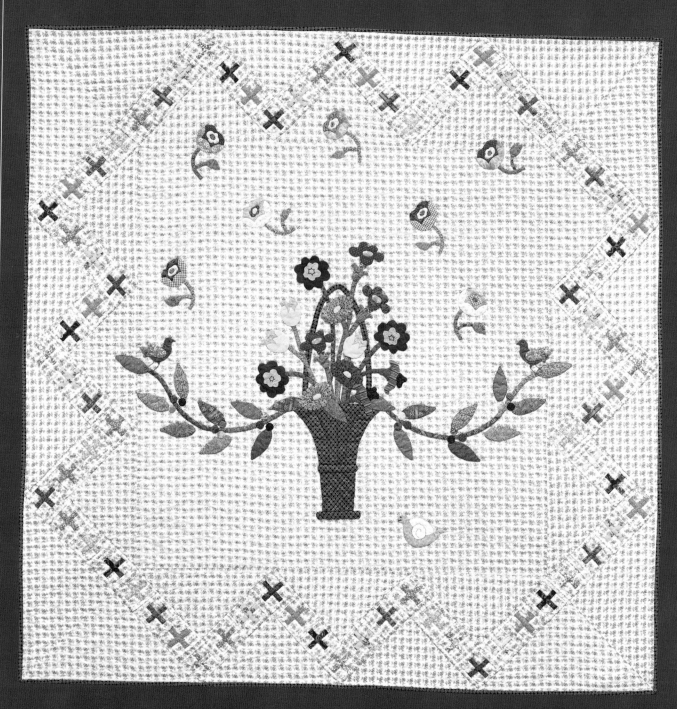

Finished Quilt: 60" x 60"

Finished Embroidered Kisses Border Block: 3" x 3"

For the average worker in early nineteenth-century England, life was harsh. In response, society sought beauty and escape in a growing feeling of romanticism, tempered by Queen Victoria's sense of morality. It would have been scandalous to ask a lover outright to escape city life for a romantic holiday, but a man could always present his invitation through a composed bouquet.

Materials

Yardage is based on 42"-wide fabric.

4⅜ yards of pink print for background of center block, border blocks, and setting triangles

1¼ yards of brown fabric for basket, handle, and binding

1 yard *total* of assorted green fabrics for stems, leaves, and flowers

⅝ yard *total* of 8 fabrics for border blocks

½ yard *total* of assorted red and pink fabrics for flowers and berries

½ yard *total* of assorted blue fabrics for flowers and birds

½ yard *total* of assorted yellow fabrics for flowers and snail

Scrap of white fabric for snail

3¾ yards of fabric for backing

66" x 66" piece of batting

Template plastic

Sheet of No-Melt Mylar

Lightweight, nonwoven fusible interfacing

¼", ⅜", and ½" bias press bars

¼" paper-backed fusible-web tape

Embroidery floss

Cutting

All strips are cut across the width of the fabric unless indicated otherwise.

From the pink print, cut:

1 square, 40" x 40"

16 strips, 1⅜" x 42"

11 strips, ⅞" x 42"; crosscut into 152 rectangles, ⅞" x 2¾"

14 strips, ⅞" x 42"; crosscut into 152 rectangles, ⅞" x 3½"

5 squares, 14" x 14"; cut twice diagonally to yield 20 side setting triangles

2 squares, 17⅞" x 17⅞"; cut once diagonally to yield 4 corner setting triangles

From the brown fabric, cut:

7 strips, 2½" x 42"

Approximately 28" of 1½"-wide bias strips

From the assorted green fabrics, cut:

Approximately 138" of 1¼"-wide bias strips

Approximately 32" of 1"-wide bias strips

From *each* of the 8 border block fabrics, cut:

2 strips, 1" x 42"; crosscut 1 strip into 10 rectangles, 1" x 2¾"

Appliquéing the Center Block

Refer to "Appliqué" on page 9 as needed to complete the following steps.

1. Use the patterns on pages 31–35 to prepare and label all the templates.

2. Use templates and fusible interfacing to prepare the basket, flowers, leaves, birds, and snail.

3. Use the template and No-Melt Mylar to prepare circles for berries.

4. Use the 1" green bias strips and ¼" bias press bar to make the stems for the poppies. Use the 1¼" green bias strips and ⅜" bias press bar to make the remaining stems. Use the 1½" brown bias strips and ½" bias press bar to make the basket handle.

5. Fold the 40" pink square in half in both directions to help with appliqué placement. Refer to the placement diagram at top right to arrange the basket and handle. Use your

Victorian Flower	Sentiment
Aster	"Sentimental Recollections"
Garden Anemone	"Hope"
Honeysuckle	"Bonds of Love"
Mistletoe	"Splendors of Kissing"
Poppy	"Evanescent Pleasure"
Primrose	"Wait for Me"
Sweet Pea	"An Appointed Meeting"

Young ladies in the nineteenth century played a game using flowers to determine a future consort's character. Out of a gathered bouquet of many different varieties, each blindfolded girl would draw a flower. If, for example, a primrose were picked, this signified that the gentleman would be simple and candid.

preferred stitch to appliqué all edges of the shapes except where the basket is filled with flowers.

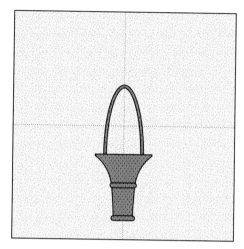

Basket and handle placement

6. Arrange the stems, leaves, basket flowers, four poppies, and snail on the square as shown. (Because the swag extends slightly onto the border section, retain four mistletoe leaves and three berries to add after sewing the border to the quilt.) Fuse the appliqués in place. Use your preferred stitch to appliqué all edges of the shapes, and use hand embroidery to add detail to the flowers and the snail as indicated on the template patterns.

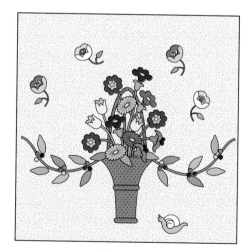

Appliqué placement

7. Press the block and trim it to 38¾" x 38¾".

Piecing the Embroidered Kisses Border Blocks

1. Sew a 1⅜" x 42" pink strip to each side of each 1" x 42" border block fabric strip. Press seams toward the border block fabric. Make eight total. Crosscut all strip sets into 1⅜" x 2¾" segments. Make 152.

Make 8 strip sets.
Cut 19 segments from each strip set (152 total).

2. Sew two segments from step 1 with one matching 1" x 2¾" border block rectangle. Press seams toward the rectangle. Make 80. (You will only use 76.)

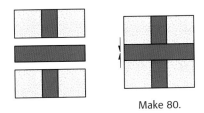

Make 80.

3. Sew one ⅞" x 2¾" pink rectangle to opposite sides of each block. Press seams toward the rectangles. Sew one ⅞" x 3½" pink rectangle to the remaining sides of each block. Press seams toward the rectangles. All blocks should now measure 3½".

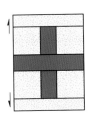
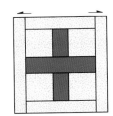

4. Join 60 of the blocks into 20 units of three blocks each. Arrange colors of the blocks evenly throughout the units. Press seams open.

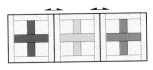

Make 20.

5. Join the remaining 16 blocks into four units of four blocks each. Press seams open.

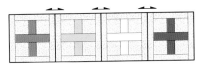

Make 4.

6. Arrange five of the 14" pink triangles with five of the three-block units.

7. Sew each three-block unit to the side setting triangles as shown, and then join a four-block unit to the remaining short side of the first triangle. Press seams toward the triangles.

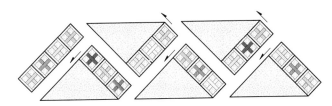

8. Sew the triangle units together. Press seams toward the triangles. Repeat for the remaining three borders.

Outside edge

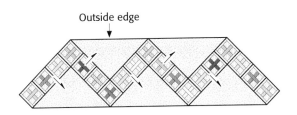

Assembling the Quilt Top

1. Because the borders are partially mitered, you'll need to mark the seam points on the center block and the pieced borders. Mark a small dot ¼" in from each end of the border sections as well as on all four corners of the center block.

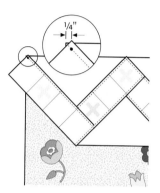

2. Align one border section with the center block, matching the dots, and pin in place. Stitch, beginning and ending the seam at the dots. Press the seam allowance toward the border. Repeat for the opposite side of the center block.

3. Sew the remaining two border sections to the center block in the same manner. Press seam allowances toward the border.

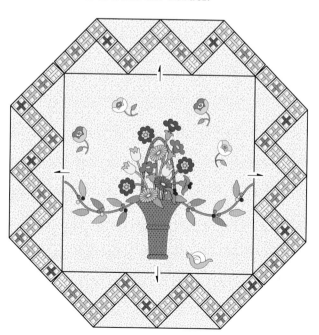

4. Fold the quilt top so that the ends of adjacent borders are right sides together with the raw edges even. The seam allowance at each corner should be folded out of the way. Stitch from the inside of the border to the outer edge. Press the seam open. Repeat for the remaining three corners.

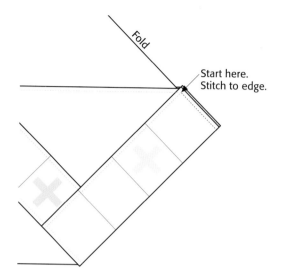

5. Sew the 17⅞" triangles to the corners of the quilt. Press toward the triangles.

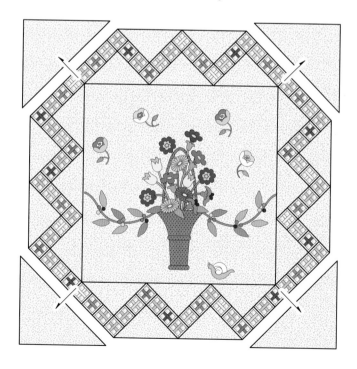

Appliquéing the Mistletoe Swag and Birds

Referring to the photo on page 26, arrange the remaining leaves, stems, and birds in place. The swag extends a little bit into the border section; fuse it in place, and then appliqué the shapes, using your preferred stitch. Finish appliquéing the top of the basket to close any gaps. Use hand embroidery to add details to the birds.

Finishing the Quilt

Refer to "Finishing" on page 15 to layer, quilt, and bind your quilt.

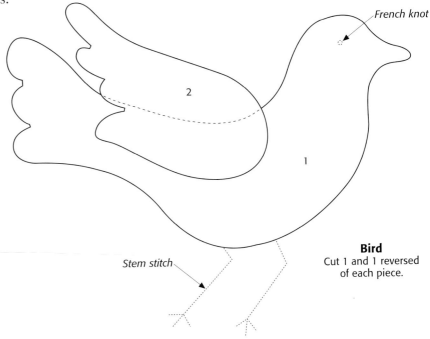

French knot

2

1

Stem stitch

Bird
Cut 1 and 1 reversed of each piece.

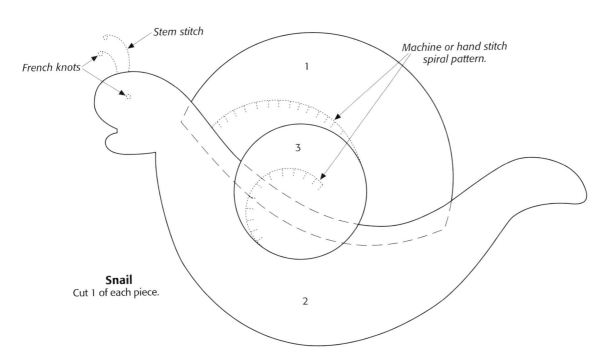

Stem stitch

French knots

Machine or hand stitch spiral pattern.

1

3

Snail
Cut 1 of each piece.

2

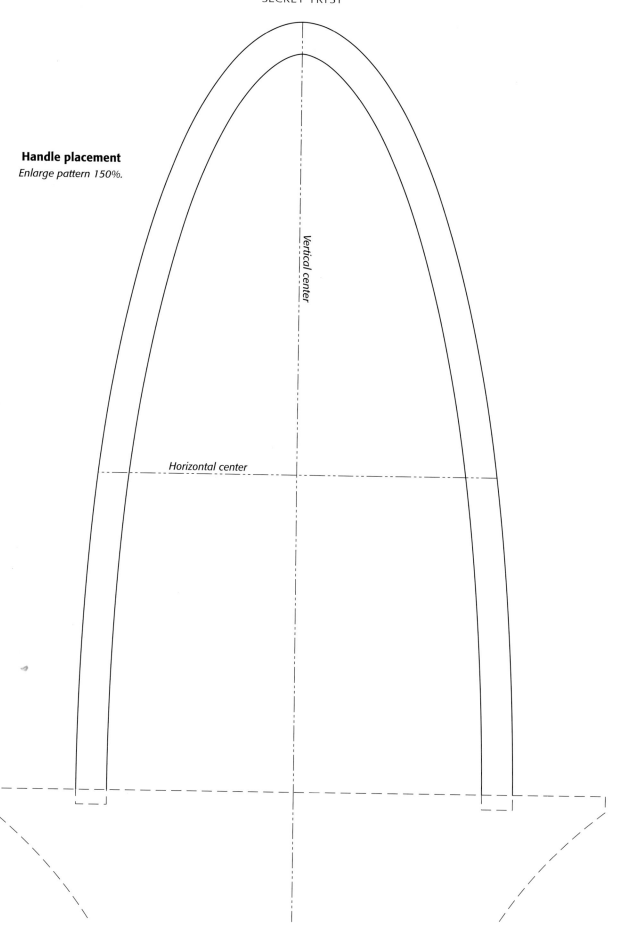

Handle placement
Enlarge pattern 150%.

Vertical center

Horizontal center

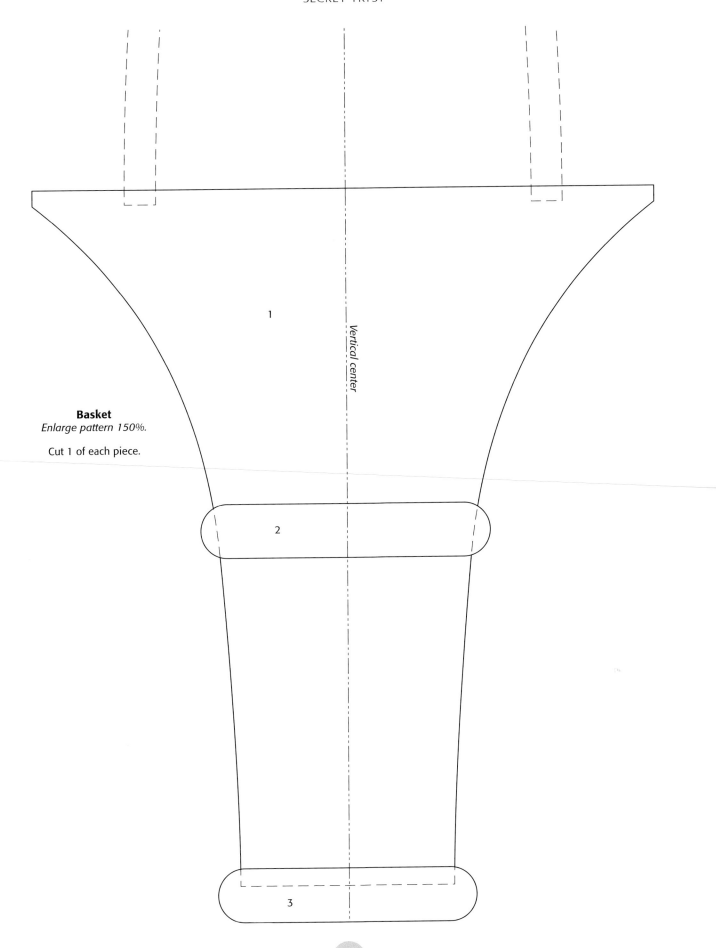

Basket
Enlarge pattern 150%.

Cut 1 of each piece.

1

Vertical center

2

3

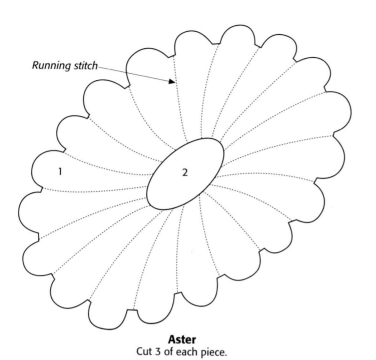

Running stitch

Aster
Cut 3 of each piece.

Garden anemone
Cut 3 of each piece.

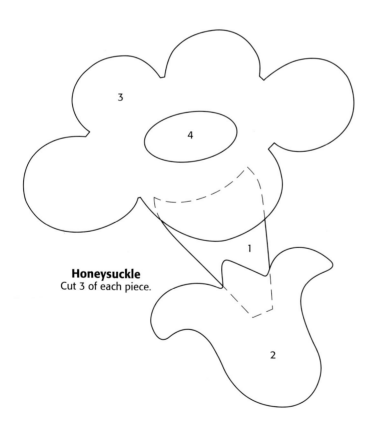

Honeysuckle
Cut 3 of each piece.

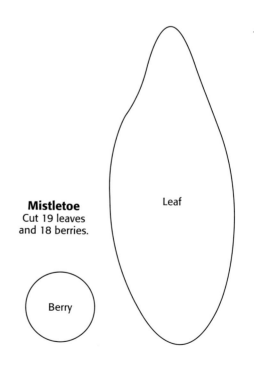

Mistletoe
Cut 19 leaves
and 18 berries.

Leaf

Berry

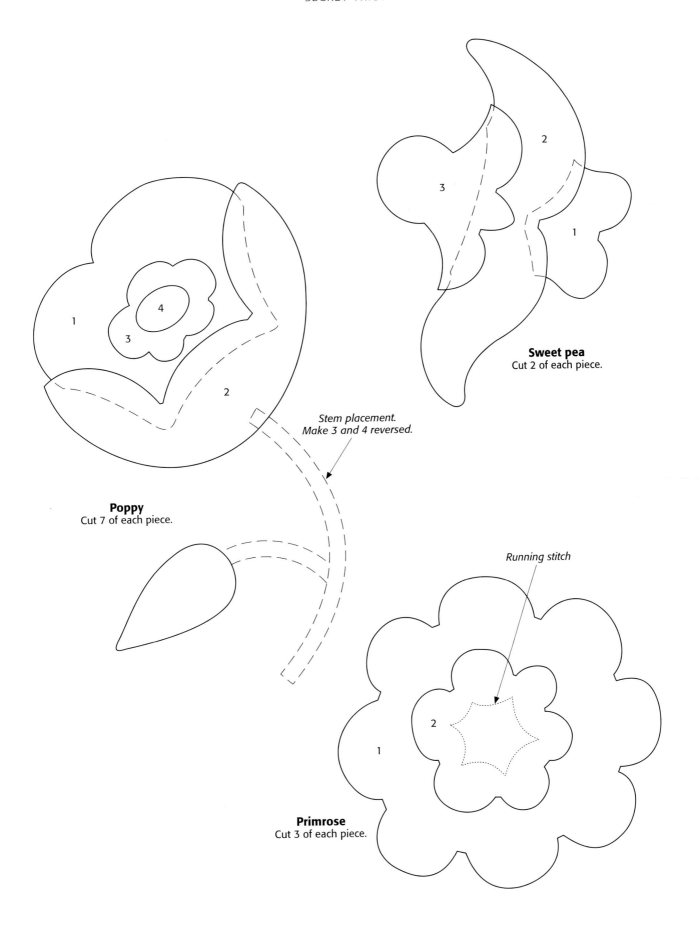

Sweet pea
Cut 2 of each piece.

*Stem placement.
Make 3 and 4 reversed.*

Poppy
Cut 7 of each piece.

Running stitch

Primrose
Cut 3 of each piece.

True Love

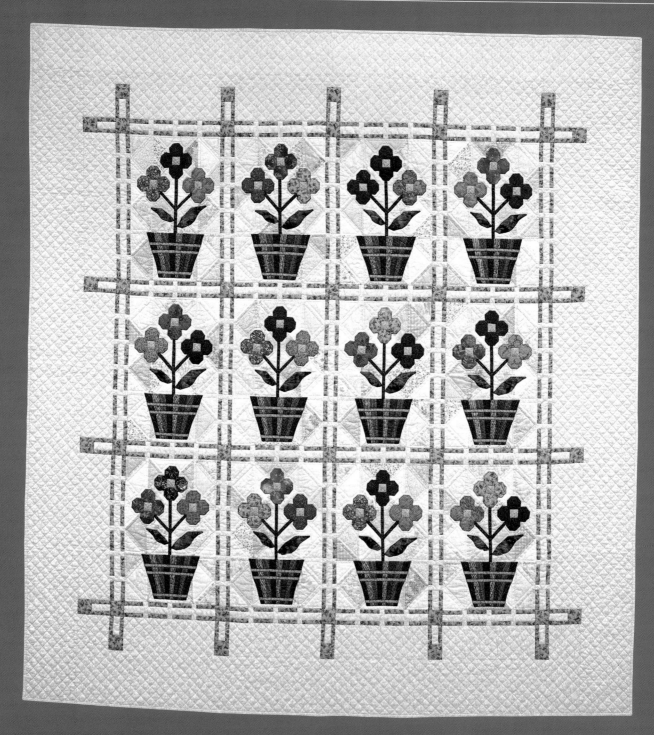

Finished Quilt: 87¾" x 92¼"

Finished Forget-Me-Not Block: 13" x 19½"

Finished Sashing Block: 2" x 2⅝"

The forget-me-not means "you are loved" in Victorian floral dream interpretation, and this delicate flower has been worn for centuries as an emblem of loyalty. One legend has it that the forget-me-not got its name from the story of a young man who waded into an icy stream to pluck the flowers from a small island nearby, but he was overcome by the current. Before he was swept downstream, he threw the flowers toward his waiting lover and cried, "Forget me not!!"

Materials

Yardage is based on 42"-wide fabric.

5½ yards of main background fabric for sashing, borders, and binding

5¼ yards of assorted background fabrics for Forget-Me-Not blocks

⅓ yard *each* of 4 brown fabrics for the market pots

1⅛ yards of aqua fabric for sashing and cornerstones

⅞ yard *total* of assorted blue and purple fabrics for forget-me-not flowers

⅝ yard of green fabric for stems and leaves

¼ yard of tan fabric for market pot bands

¼ yard of yellow fabric for flower centers

8¼ yards of backing fabric

94" x 99" piece of batting

Template plastic

Lightweight, nonwoven fusible interfacing

¼" bias press bar

¼" paper-backed fusible-web tape

Note: In the quilt shown, 5 different fabrics were used to make the market pots. We simplified the instructions so that only 4 fabrics are required.

Cutting

All strips are cut across the width of the fabric unless indicated otherwise.

From the assorted background fabrics, cut:

15 strips, 3¾" x 42"; crosscut into 144 squares, 3¾" x 3¾"

15 strips, 3¾" x 42"; crosscut into 72 rectangles, 3¾" x 7"

36 squares, 7¾" x 7¾"

From the tan fabric, cut:

6 strips, 1" x 42"

From the fusible interfacing, cut:

36 squares, 5" x 5"

From the assorted blue and purple fabrics, cut:

36 squares, 5" x 5"

From the yellow fabric, cut:

5 strips, 1¼" x 42"; crosscut into 144 squares, 1¼" x 1¼"

From the green fabric, cut:

6 strips, 1" x 42"

From the aqua fabric, cut:

28 strips, 1" x 42"

3 strips, 2½" x 42"; crosscut into 38 squares, 2½" x 2½"

From the lengthwise grain of the main background fabric, cut:

2 strips, 8½" x 71¾"

2 strips, 8½" x 92¼"

From the remaining width of the main background fabric, cut:

14 strips, 1½" x 42"

8 strips, 1¼" x 42"; crosscut into 123 rectangles, 1¼" x 2½"

6 strips, 5⅛" x 42", crosscut into:
 4 squares, 5⅛" x 5⅛"
 8 rectangles, 5⅛" x 13½"
 6 rectangles, 5⅛" x 20"

10 strips, 2½" x 42"

Piecing the Background of the Forget-Me-Not Blocks

1. To make a flying-geese unit, place a 3¾" background square on one end of a 3¾" x 7" background rectangle with right sides together. Sew diagonally across the square from corner to corner. Trim ¼" from the seam and press the seam toward the triangle. Repeat at the other end of the rectangle using a different background square fabric, if desired. Make 72.

Make 72.

2. To make a quarter-square-triangle unit, place two 7¾" background squares with right sides together. Draw a line diagonally on the wrong side of one square. Sew ¼" on each side of the line. Cut the squares in half on the line and press seams toward the same fabric. Repeat to make 36.

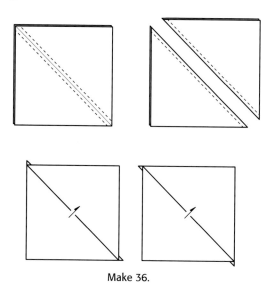

Make 36.

3. Place the pieced squares right sides together with seams nestled against each other. Combine different sets of half-square-triamgle units to achieve the greatest variety within each background block. Draw a line diagonally that crosses the previous seam. Sew ¼" on each side of the line. Cut the squares in half on the line and press the seams to one side. Make 36.

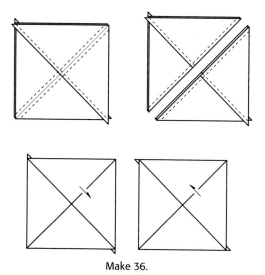

Make 36.

4. Arrange the flying-geese units and quarter-square-triangle units into blocks as shown. Sew the units together in each row and press

the seams in opposite directions from row to row. Sew the rows together and press. Make 12 blocks.

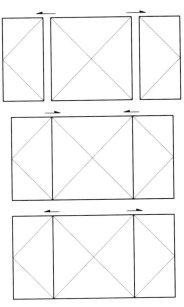

Forget-Me-Not block assembly.
Make 12.

Piecing the Market Pots

Refer to "Appliqué" on page 9 as needed to complete the following steps.

1. Use the patterns on page 43 to prepare and label all the templates.

2. With opposite selvages together, stack the ⅓-yard pieces of brown fabric on top of each other, aligning the folds. Match the grain line arrow of the template to the grain of the fabric and trace around the template. Rotate the template on the fabric until you have traced 12 wedges as shown. Each stack of eight wedges will make one market pot. Cut the wedges.

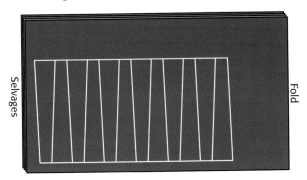

Cutting diagram for market pot wedges

3. Sew the wedges together with all pieces facing in the same direction. Press all the seams to one side. The wedge unit will now be curved.

4. Place a ruler across the bottom of the wedge unit, with a line of the ruler even with the center seam of the unit. Trim the bottom of the unit. Cut again 6½" from the bottom.

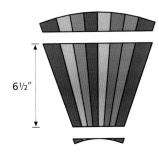

6½"

5. The market pots are appliquéd with tan bands. Referring to "Bias and Straight-Grain Strips" on page 10, use the 1" tan strips, ¼" bias press bar, and paper-backed fusible-web tape to make the bands.

6. Mark the placement for the bands on each pot. From the top of the pot, measure down 1½", 2½", and 5", drawing a line horizontally at each position. Position the upper edge of the tan band along each placement line as shown. Fuse in place, and then appliqué the edges on both sides of the bands. Trim the ends of the bands even with the edges of the pot. Make 12.

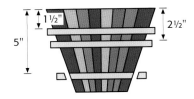

39

7. Place the right side of each market pot against the fusible side of the interfacing and stitch ¼" from the raw edges around the perimeter of the pot, using a stitch length of 18 to 20 stitches per inch. Cut out the pots using a scant ¼" seam allowance. Carefully cut a small slit in the interfacing only and turn the pot right side out. Use a point turner to push out the corners and smooth the edges.

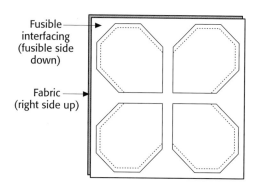

Market pot

Forget-Me-Not Flowers

1. To make one flower, trace four petals onto the nonadhesive side of a 5" square of fusible interfacing, leaving about ½" between each petal. Place the adhesive side of the interfacing square against the right side of a 5" flower square. Stitch *only where indicated on the pattern*. Use a stitch length of 18 to 20 stitches per inch.

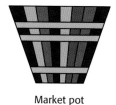

Fusible interfacing (fusible side down)

Fabric (right side up)

2. Cut the petals apart from each other, ⅛" from the seam. Cut directly on the solid line of each pattern. Turn right side out and use a point turner to smooth all seam lines and corners. Press flat with a wooden press bar.

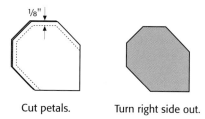

⅛"

Cut petals. Turn right side out.

3. With right sides together, place a 1¼" yellow square on the inside corner of each petal and stitch diagonally from corner to corner. Trim ¼" from the seam and fold the triangle over to form the petal point. Press with a wooden press bar.

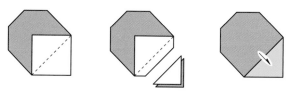

4. Using a ¼" seam allowance, stitch two petals together and use a wooden press bar to press the seam to one side. Repeat.

5. Sew two sets of petals together to complete a flower. Finger-press the seam open. Make 36.

Make 36.

Appliquéing the Block

Refer to "Appliqué" on page 9 as needed to complete the following steps.

1. Use the 1" green strips to make the flower stems.

2. Use the templates and fusible interfacing to prepare the leaves.

3. Following the placement diagram, arrange the flowers, stems, leaves, and market pots. Fuse to secure.

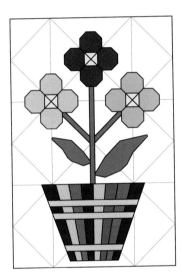

Appliqué placement

4. Appliqué all shapes in place using your preferred stitch.

Piecing the Sashing

1. Sew one 1" x 42" aqua strip to each side of one 1½" x 42" background strip. Press the seams toward the aqua strips. Make 14. From 11 of the strip sets, crosscut 140 segments, 3⅛" wide. From the remaining three strip sets, crosscut 32 segments, 3¼" wide.

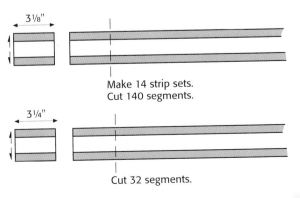

Make 14 strip sets.
Cut 140 segments.

Cut 32 segments.

2. Join six 3⅛" segments with five 1¼" x 2½" background rectangles. Press seams toward the rectangles. Make 15.

Make 15.

3. Join two 3⅛" segments with three 1¼" x 2½" background rectangles. Press the seams toward the rectangles. Add a 3¼" segment to each end. Make 16.

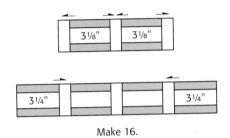

Make 16.

4. Join the remaining 3⅛" segments to 2½" aqua squares. Press the seams toward the square. Make 18 end units.

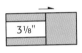

Make 18.

Assembling the Quilt Top

1. Following the quilt assembly diagram, sew the rows of the quilt. For the horizontal sashing rows, join two sashing end units, five 2½" x 2½" aqua squares, and four sashing sections consisting of four segments each. Press seams toward the aqua squares. Make four.

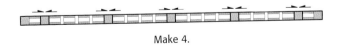

Make 4.

2. For the flower rows, join two 5⅛" x 20" background rectangles, five sashing sections consisting of five segments each, and four Forget-Me-Not blocks. Press seams toward the blocks. Make three.

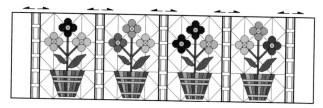

Make 3.

3. For the top and bottom rows, join two 5⅛" background squares, five sashing end units, and four 5⅛" x 13½" background rectangles. Press seams away from the sashing units. Make two.

Make 2.

4. Sew the rows together and press.

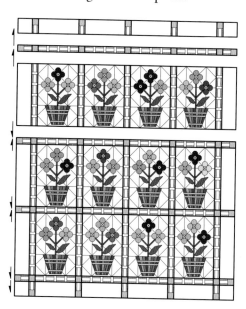

5. Sew the 71¾" background strips to the top and bottom of the quilt. Press seams toward the borders.

6. Sew the 92¼" background strips to the sides of the quilt. Press seams toward the borders.

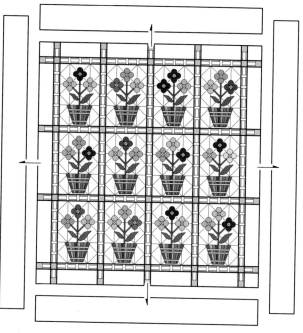

Quilt assembly

Finishing the Quilt

Refer to "Finishing" on page 15 to layer, quilt, and bind your quilt.

Victorian Flower	Sentiment
Forget-Me-Not	"True Love" or "Forget-Me-Not"

The fairy kingdom was protected by secret doorways that could only be opened by a few key flowers, of which the forget-me-not was one. To open the secret doorway, you had to press the flower to the mountainside and—just as if you had uttered the magic phrase, "Open sesame"—the doors to this enchanted land would become visible and fling open.

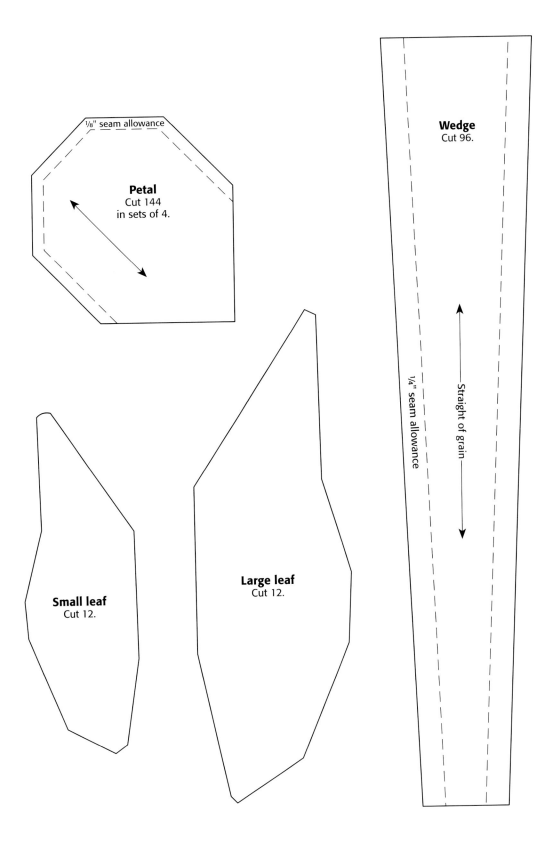

⅛" seam allowance

Petal
Cut 144
in sets of 4.

Wedge
Cut 96.

¼" seam allowance

Straight of grain

Small leaf
Cut 12.

Large leaf
Cut 12.

Affection's Offering

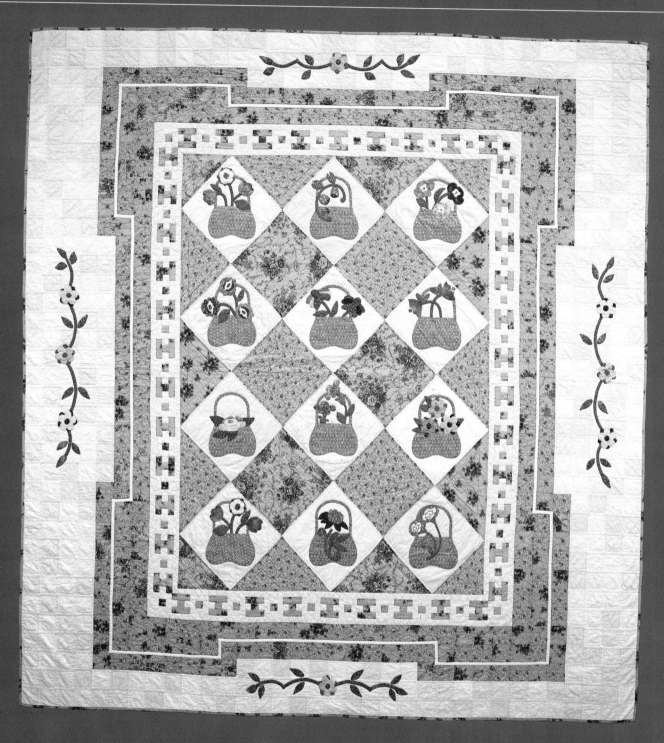

Finished Quilt: 102½" x 108½"

Finished Soggy Bottom Basket Block: 11¾" x 11¾"

Finished Basket Weave Border Block: 3" x 3"

Honeysuckle and roses are just two of the popular flowers used in this quilt. Known as "Love Bind" or "Wild Woodbine," honeysuckle was a flower with many uses. It was exchanged by French lovers to symbolize their union; it was used in the creation of love potions; and, according to legend, its honey nectar was a favorite drink of fairies at their own weddings. If you dream of honeysuckle, it foretells "a change of address."

The rose is the ancient Roman's emblem of joy, represented by Comus, the God of Pleasure. If you dream of roses, it means "love is on its way."

Materials

Yardage is based on 42"-wide fabric.

6½ yards *total* of assorted tan fabrics for alternate blocks, setting triangles, borders B and D, and binding

5¾ yards *total* of assorted white and cream fabrics for background of Soggy Bottom Basket blocks and borders D and E

1½ yards of cream fabric for borders A, B, and C

1 yard of tan fabric for baskets and handles

1 yard *total* of assorted pink, blue, and violet fabrics for flowers

1 yard *total* of assorted green fabrics for leaves and stems

½ yard of white fabric for appliquéd border accent strip

9 yards of backing fabric

108" x 114" piece of batting

Template plastic

Sheet of No-Melt Mylar

Lightweight, nonwoven fusible interfacing

½" bias press bar

¼" paper-backed fusible-web tape

Embroidery floss

Cutting

All strips are cut across the width of the fabric unless indicated otherwise.

From the tan fabric for baskets and handles, cut:
168" of 1½"-wide bias strips

From the assorted green fabrics, cut:
232" of 1½"-wide bias strips

From the assorted white and cream fabrics, cut:
12 squares, 12¼" x 12¼"

440 squares, 3½" x 3½"

From the cream fabric, cut:
16 strips, 1½" x 42". From 8 of the strips, cut 84 rectangles, 1½" x 3½".

10 strips, 2" x 42"

4 strips, 1¼" x 42"

From the assorted tan fabrics, cut:

12 strips, 1½" x 42". From 8 of the strips, cut 84 rectangles, 1½" x 3½".

264 squares, 3½" x 3½"

6 squares, 12¼" x 12¼"

3 squares, 17¾" x 17¾". Cut twice diagonally to yield 10 side setting triangles.

2 squares, 9⅜" x 9⅜". Cut once diagonally to yield 4 corner triangles.

11 strips, 2½" x 42"

From the white fabric for border accent, cut:

9 strips, 1½" x 42"

Appliquéing the Soggy Bottom Basket Blocks

Refer to "Appliqué" on page 9 as needed to complete the following steps.

1. Use the patterns on pages 49–54 to prepare and label all the templates.

2. Use the templates and fusible interfacing to prepare the flowers, leaves, and baskets.

3. Use the 1½" bias strips of tan and green to make the stems and basket handles.

4. Fold the 12¼" background squares diagonally in both directions and crease lightly. Trace around the basket handle template on each square. Referring to the photo on page 44, position the handles and baskets and fuse in place, leaving the top edge of the baskets open for insertion of the flowers and stems. Appliqué the edges using your preferred stitch.

5. Complete each block with hand embroidery, as needed.

Piecing the Borders

This quilt has five borders, labeled A, B, C, D, and E. Borders B, D, and E are pieced. Refer to the quilt assembly diagram on page 48 for each border position. For border A, these instructions

alter the border width slightly from what is shown in the photograph. The top and bottom A borders will be wider than the side A borders to make the remaining borders fit properly. If you prefer that the A borders have the same width on top and bottom as on the sides, then you'll need to ease the remaining pieced borders to fit.

BORDER B

1. Border B is made from Basket Weave blocks. This block is pieced in two different fabric combinations, labeled unit A and unit B.

2. To make A units, sew one 1½" x 42" cream strip to each side of a 1½" x 42" tan strip. Press seams toward the tan strip. Make four. Cut the strip sets into 84 segments, 1½" wide.

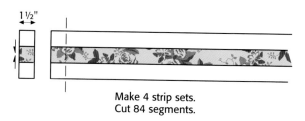

Make 4 strip sets.
Cut 84 segments.

3. Sew a 1½" x 3½" tan rectangle to each side of a strip-set segment. Press seams toward the tan rectangles. Make 42.

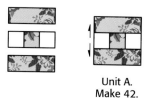

Unit A.
Make 42.

4. To make B units, sew a 1½" x 3½" cream rectangle to each side of a strip-set segment. Press seams toward the center segment. Make 42.

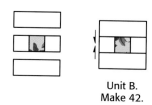

Unit B.
Make 42.

5. Sew the top and bottom border sections by joining nine A units and eight B units as shown. Press seams toward the A units.

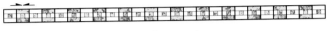

Top/bottom border B sections.
Make 2.

6. Sew the side border sections by joining 12 A units and 13 B units. Press seams toward the A units.

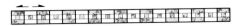

Side border B sections.
Make 2.

BORDER D

1. The top and bottom borders contain a center section and two side sections. A side section contains fifteen 3½" tan squares combined into three rows of five squares each. Press seams in alternating directions from row to row. Sew the rows together and press. Make four.

Make 4.

2. For the center section, make two rows each with ten 3½" tan squares and one row with ten 3½" cream or white squares. Press seams in alternating directions from row to row. Sew the rows together and press. Make two.

Make 2.

3. Join the sections and press. Make two.

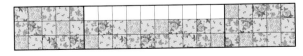

Top/bottom border D.
Make 2.

4. For the side borders, make a side section containing three rows, each with nine 3½" tan squares. Press seams in alternating directions from row to row. Sew the rows together and press. Make four.

Make 4.

5. For the center section, make two rows each with fourteen 3½" tan squares and one row with fourteen 3½" cream or white squares. Press seams in alternating directions from row to row. Sew the rows together and press. Make two.

Make 2.

6. Join the sections and press. Make two.

Side border D.
Make 2.

BORDER E

1. For the top and bottom borders, make two rows each with twenty-six 3½" cream or white squares. Press seams in alternating directions from row to row. Sew the rows together and press. Make two.

Top/bottom border E.
Make 2.

2. For the side borders, make four rows each with thirty-six 3½" cream or white squares. Press seams in alternating directions from row to row. Sew the rows together and press. Make two.

Side border E.
Make 2.

Assembling the Quilt Top

1. Arrange the Soggy Bottom Basket blocks, alternate blocks, and side and corner setting triangles. Sew the blocks and triangles together into diagonal rows. Press seams toward the alternate blocks. Sew the rows together and press.

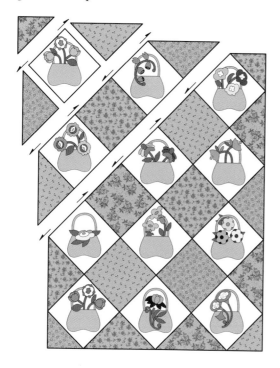

2. Sew three 2"-wide cream strips together end to end and press. From this strip, cut two pieces 50" long. Sew them to the top and bottom of the quilt for border A. Press seams toward the borders. Sew four 1¼"-wide cream strips together end to end and press. From this strip, cut two pieces 69½" long. Sew them to the quilt sides to complete border A. Press.

3. Sew the top and bottom border B sections to the quilt. Sew the side border B sections to the quilt. Press all seams toward border B.

4. For border C, sew seven 2"-wide cream strips together end to end and press. From this strip, cut two pieces 57½" long and sew them to the top and bottom of the quilt. Cut two pieces 78½" long and sew them to the quilt sides. Press all seams toward border C.

5. Sew the top and bottom border D sections to the quilt. Sew the side border D sections to the quilt. Press all seams toward border C.

6. Sew the 1½" x 42" white strips together end to end and press. Sew lengthwise into a tube and use the bias press bar to create the white border accent strip. Referring to photo on page 44, measure 3¼" from the edge of border D to position the strip. Referring to "Sharp Points from Bias Tape" on page 11, appliqué the strip to border D using your preferred stitch.

7. Sew the top and bottom border E sections to the quilt. Sew the side border E sections to the quilt. Press all seams toward border D.

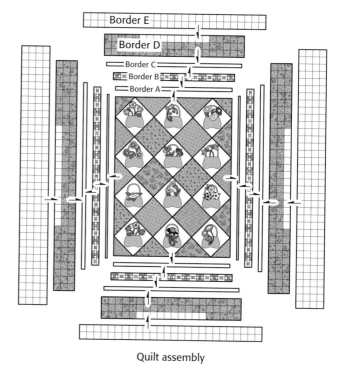

Quilt assembly

8. Using the templates, mark the placement of the Cosmos swag on the outer borders D and E. Follow the placement guide to fuse the flowers, stems, and leaves in place. Appliqué shapes using your preferred stitch.

Top/bottom border appliqué placement

Side border appliqué placement

Finishing the Quilt

Refer to "Finishing" on page 15 to layer, quilt, and bind your quilt.

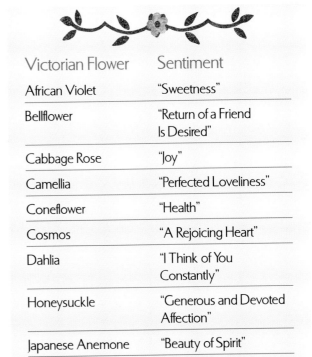

Victorian Flower	Sentiment
African Violet	"Sweetness"
Bellflower	"Return of a Friend Is Desired"
Cabbage Rose	"Joy"
Camellia	"Perfected Loveliness"
Coneflower	"Health"
Cosmos	"A Rejoicing Heart"
Dahlia	"I Think of You Constantly"
Honeysuckle	"Generous and Devoted Affection"
Japanese Anemone	"Beauty of Spirit"
Morning Glory	"Loveliness of Life"
Rose	"Grace and Beauty"
Tulip	"Happy Years"

Basket
Cut 12.

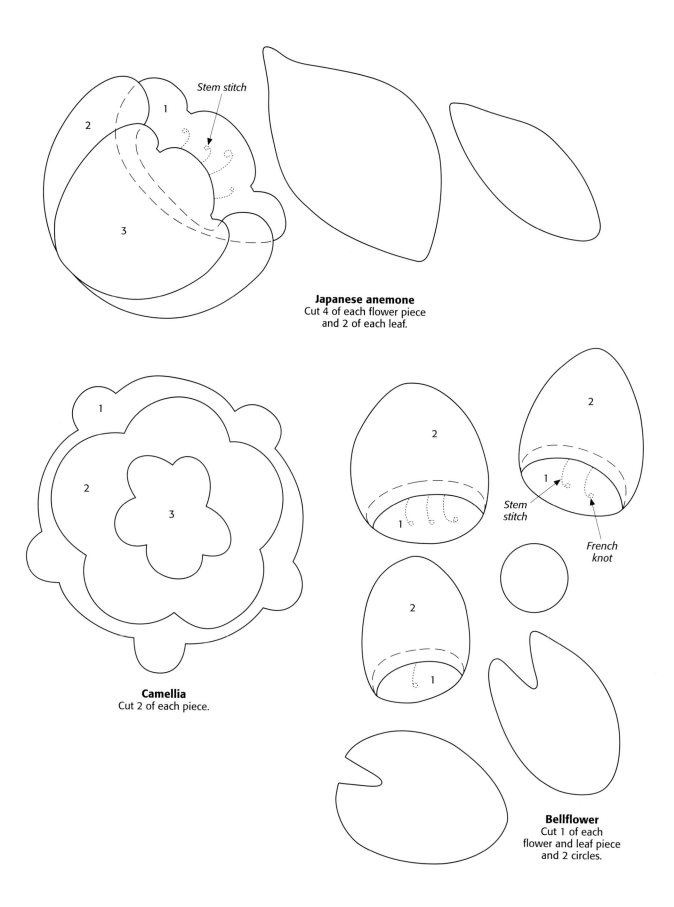

Japanese anemone
Cut 4 of each flower piece
and 2 of each leaf.

Stem stitch

Camellia
Cut 2 of each piece.

Stem stitch

French knot

Bellflower
Cut 1 of each
flower and leaf piece
and 2 circles.

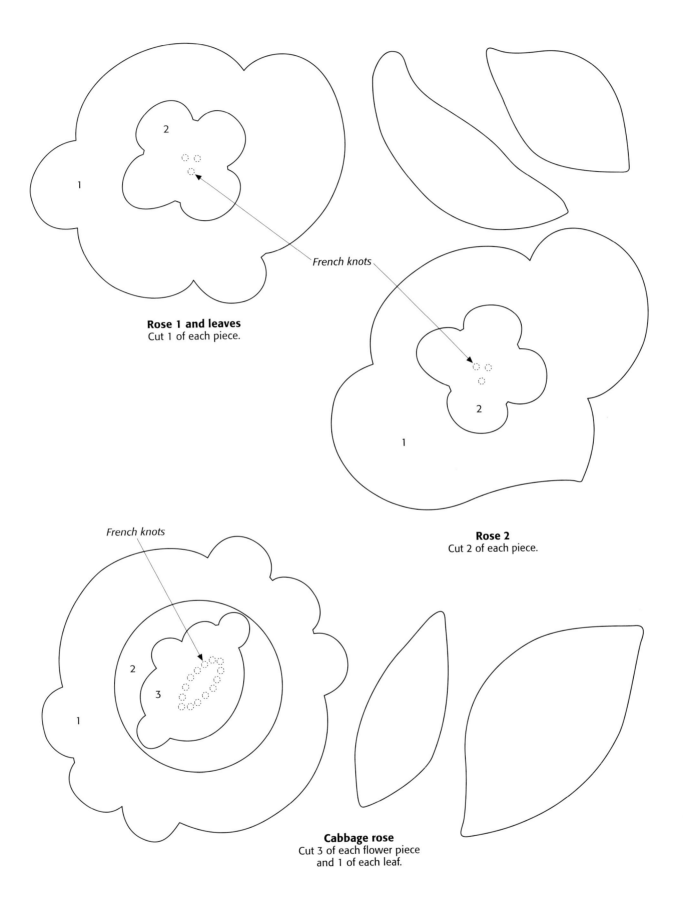

Rose 1 and leaves
Cut 1 of each piece.

French knots

Rose 2
Cut 2 of each piece.

French knots

Cabbage rose
Cut 3 of each flower piece
and 1 of each leaf.

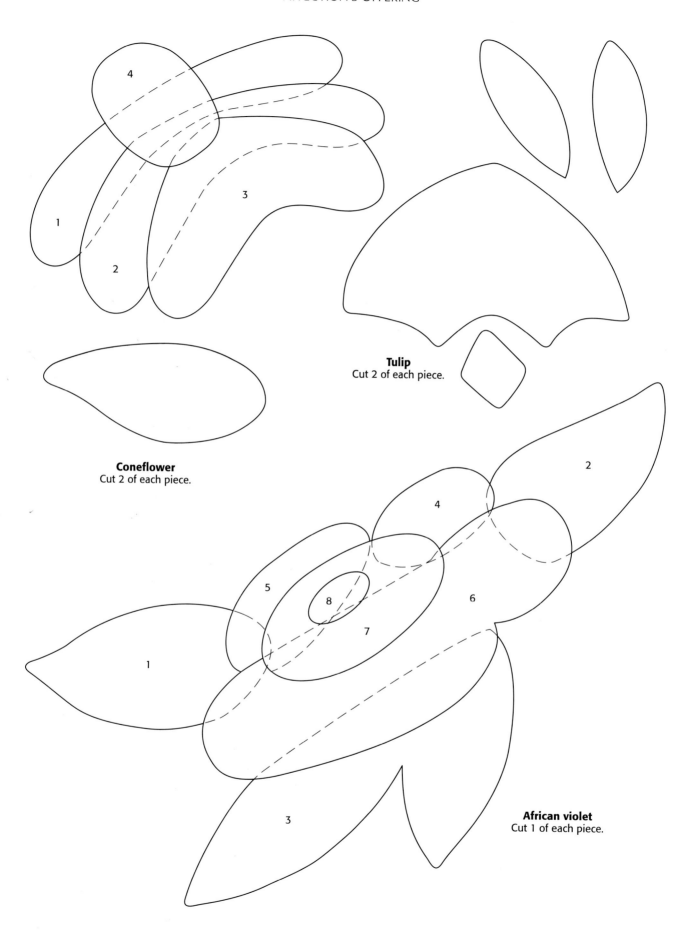

Tulip
Cut 2 of each piece.

Coneflower
Cut 2 of each piece.

African violet
Cut 1 of each piece.

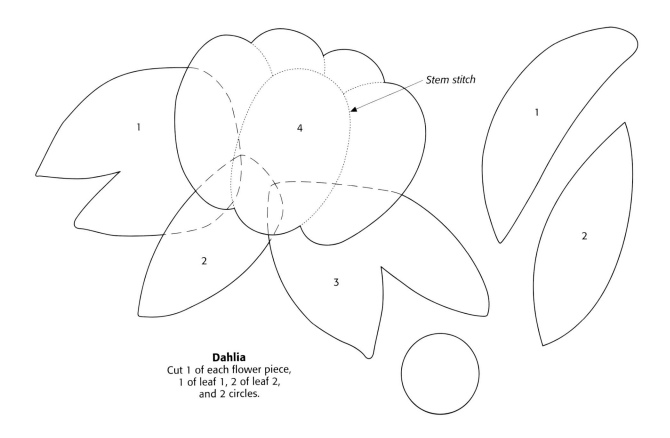

Dahlia
Cut 1 of each flower piece,
1 of leaf 1, 2 of leaf 2,
and 2 circles.

Stem stitch

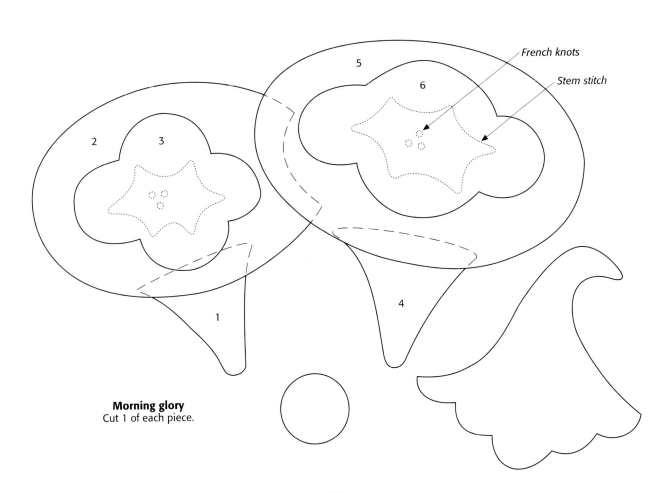

French knots

Stem stitch

Morning glory
Cut 1 of each piece.

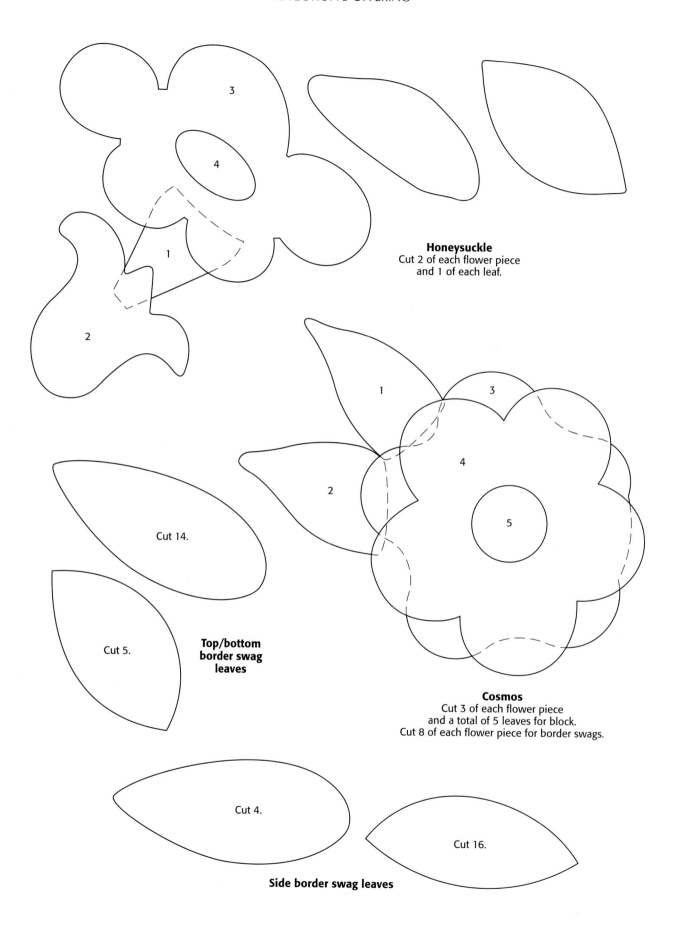

Honeysuckle
Cut 2 of each flower piece
and 1 of each leaf.

Cut 14.

Cut 5.

**Top/bottom
border swag
leaves**

Cosmos
Cut 3 of each flower piece
and a total of 5 leaves for block.
Cut 8 of each flower piece for border swags.

Cut 4.

Cut 16.

Side border swag leaves

The Love Letter

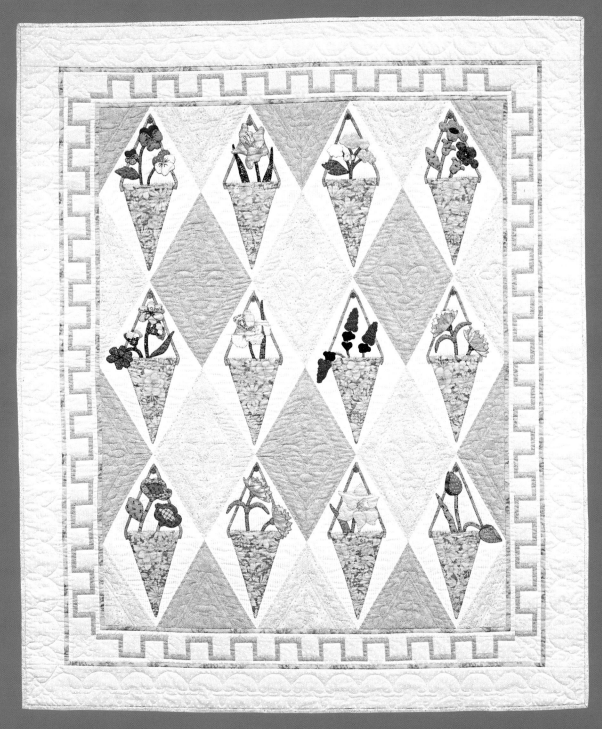

Finished Quilt: 64" x 76½"

Finished Tussie-Mussie Block: 11½" x 19⅜"

Finished Greek Key Border Block: 2½" x 2½"

"Born on a sugar plantation in the West Indies, she was christened Marie-Joseph-Rose and was called Rose by everyone who knew her until she met Napoleon Bonaparte at a dinner party. Napoleon fell madly in love with her, and in his first love letter in 1795 he renamed her Josephine. He wrote, 'Seven in the morning. I awaken full of you . . . the memory of yesterday's intoxicating evening has left no rest to my senses. . . . Sweet, incomparable Josephine, I draw from your lips, from your heart, a flame which consumes me. . . . A thousand kisses, but do not give me any, for they burn my blood.'"

Reprinted from Evangeline Bruce's *Napoleon and Josephine: An Improbable Marriage.* (Kensington Publishing Corp., 1995).

Materials

Yardage is based on 42"-wide fabric.

2 yards of cream fabric for borders

2 yards of white stripe for background of Tussie-Mussie blocks

1¾ yards of light green fabric for alternate blocks, setting triangles, and binding

1½ yards of medium green fabric for alternate blocks, setting triangles, and Greek key border

1½ yards of gold fabric for borders and baskets

1 yard *total* of assorted fabrics for flowers

½ yard *total* of assorted green fabrics for stems and leaves

4¾ yards of backing fabric

71" x 83" piece of batting

Template plastic

Lightweight, nonwoven fusible interfacing

¼" and ⅜" bias press bars

¼" paper-backed fusible-web tape

Embroidery floss

12 small buttons

Cutting

All strips are cut across the width of the fabric unless indicated otherwise. Patterns for the diamond, side triangle, top/bottom triangle, and corner triangle are on pages 60–61. Cutting layout diagrams for cutting these pieces are on pages 57–58.

From the white stripe, cut:
12 diamonds (See "Cutting Layout" on page 57.)

From the assorted green fabrics, cut:
64" of 1"-wide bias strips

58" of 1¼"-wide bias strips

From the gold fabric, cut:
19 strips, 1" x 42"

From the medium green fabric, cut:
13 strips, 1" x 42"; crosscut 7 of the strips into 86 rectangles, 1" x 3"

3 diamonds*

3 top/bottom triangles*

2 corner triangles*

2 side triangles*

From the light green fabric, cut:

8 strips, 2½" x 42"

3 diamonds*

3 top/bottom triangles*

2 corner triangles*

2 side triangles*

From the cream fabric, cut:

6 strips, 2½" x 42"

1 strip, 3" x 42"; crosscut into:
 2 rectangles, 2½" x 3"
 4 squares, 3" x 3"

12 strips, 1" x 42"

7 strips, 5" x 42"

See "Cutting Layout" on page 58.

Appliquéing the Tussie-Mussie Blocks

Refer to "Appliqué" on page 9 as needed to complete the following steps.

1. Use the patterns on pages 60–67 to prepare and label all the templates.

2. Use the templates and fusible interfacing to prepare the flowers, leaves, and baskets.

3. Use seven of the 1" gold strips and the ¼" bias press bar to make the basket handles.

4. Use the 1" green bias strips and the ¼" bias press bar to make stems. Use these stems for the following blocks: Pansy, Gladiolus, Iris, English Lavender, Rose, Jonquil, and Tulip. Use the 1¼" green bias strips and the ⅜" bias press bar to make stems. Use these stems for the following blocks: Yarrow, Honeysuckle, Peach, Carnation 1, and Carnation 2.

5. Cut out 12 white stripe diamonds using the diamond pattern on page 60 and the cutting layout shown below.

Fold

Selvages

Cutting layout

6. Fold the diamonds in half in both directions and crease lightly to mark centering lines. Position the shapes and fuse in place. Appliqué using your preferred machine stitch. Add hand or machine embroidery. Finish each block by sewing a button at the top of the handle.

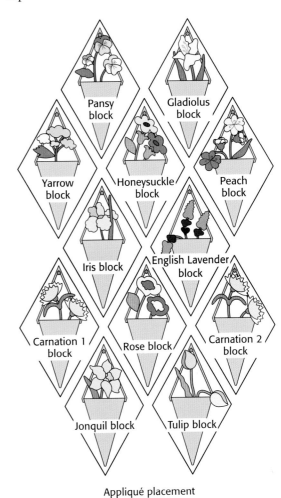

Appliqué placement

Piecing the Greek Key Border

1. To make unit A, sew a 1" x 42" medium green strip to a 2½" x 42" cream strip. Press toward the green strip. Make six. Cut the strip sets into 84 segments, 2½" wide.

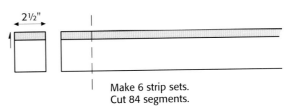

2½"

Make 6 strip sets.
Cut 84 segments.

2. Sew a 1" x 3" medium green rectangle to each of the strip-set segments as shown. Press toward the green rectangle.

Unit A.
Make 84.

3. Sew a 2½" x 3" cream rectangle to a 1" x 3" medium green rectangle as shown for unit B. Make two.

Unit B.
Make 2.

4. For the top and bottom borders, start from the left, positioning the first A unit with a green rectangle on the bottom and the other green rectangle on the right. Rotate 18 units, maintaining the pattern. Add a B unit to the end to complete each border. Press seams toward the green rectangles.

Top/bottom border.
Make 2.

5. For the side borders, repeat step 4 using 24 A units. Instead of sewing a B unit to one end, sew a 3" cream square to each end of both borders and press seams toward the cream squares.

Side border.
Make 2.

Assembling the Quilt Top

1. Cut three diamonds, two side triangles, three top/bottom triangles, and two corner triangles from both the light and medium green fabrics.

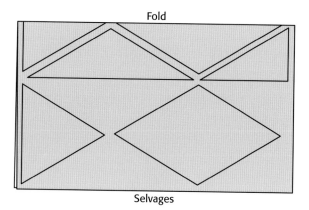

Fold

Selvages

Cutting layout

2. Follow the diagram to arrange the appliqué blocks, alternate blocks, and setting triangles. Sew the blocks together in diagonal rows. Press the seams toward the alternate blocks. Sew the rows together. Press. Trim the edges of the quilt to ¼" from the block points.

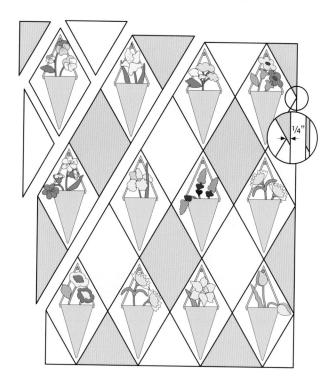

3. Sew the 1" gold strips together end to end and press. From this strip, cut two pieces 46" long, two pieces 54" long, two pieces 59½" long, and two pieces 67½". Sew a 46" strip to the top and bottom of the quilt. Sew a 59½" strip to the sides of the quilt. Press all seams toward the gold strips.

4. Sew the 1" cream strips together end to end and press. From this strip, cut two pieces 47" long, two pieces 53" long, two pieces 60½" long, and two pieces 66½". Sew the 47" strips to the top and bottom of the quilt and the 60½" strips to the sides of the quilt. Press all seams toward the gold strips.

5. Sew a Greek key border to the top and bottom of the quilt. Sew a Greek key border to the sides of the quilt. Press all seams toward the cream strips.

6. Sew a 53" cream strip to the top and bottom of the quilt. Sew a 66½" cream strip to the sides of the quilt. Press all seams toward the cream strips.

7. Sew a 54" gold strip to the top and bottom of the quilt. Sew a 67½" gold strip to the sides of the quilt. Press all seams toward the gold strips.

8. Sew the 5" cream strips together end to end and press. From this strip, cut two strips 55" long and two strips 76½" long. Sew a 55" strip to the top and bottom of the quilt. Sew a 77" strip to the sides of the quilt. Press all seams toward the cream strips.

Finishing the Quilt

Refer to "Finishing" on page 15 to layer, quilt, and bind your quilt.

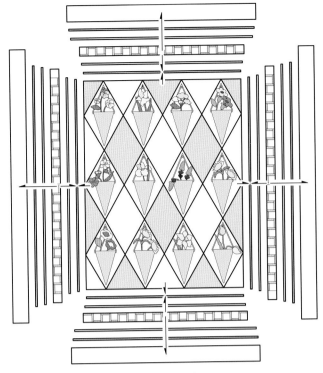

Quilt assembly

Victorian Flower	Sentiment
Carnation	"Ardent and True Love"
English Lavender	"Soothes the Tremblings and Passions of the Heart"
Gladiolus	"Cupid's Arrow Has Pierced My Heart"
Honeysuckle	"Bonds of Love"
Iris	"Flame"
Jonquil	"Have Pity on My Passion"
Peach	"I Am Your Captive"
Purple Rose	"Sorrow"
Tulip	"The Perfect Lover"
Yarrow	"Cure for Heartache"

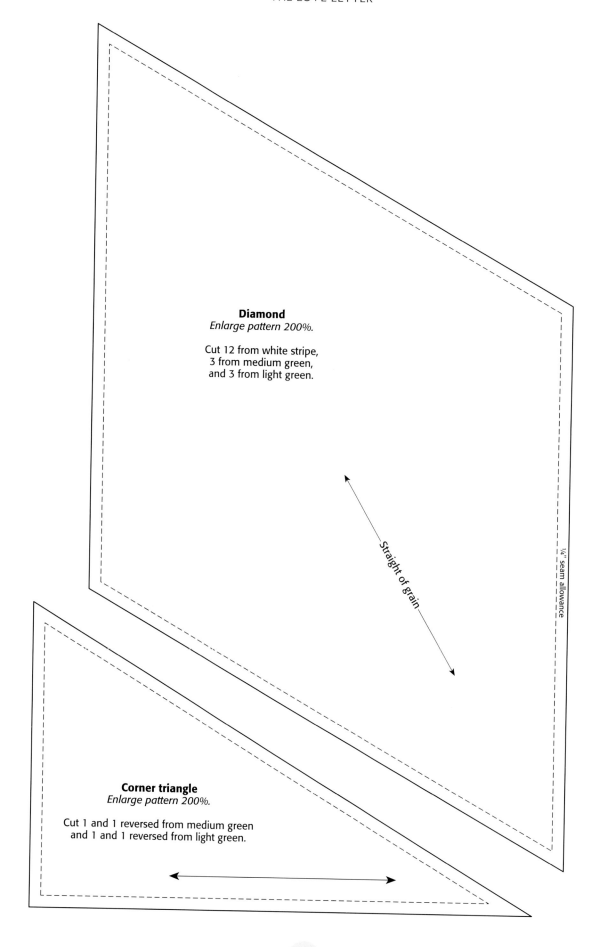

Diamond
Enlarge pattern 200%.

Cut 12 from white stripe,
3 from medium green,
and 3 from light green.

Straight of grain

¼" seam allowance

Corner triangle
Enlarge pattern 200%.

Cut 1 and 1 reversed from medium green
and 1 and 1 reversed from light green.

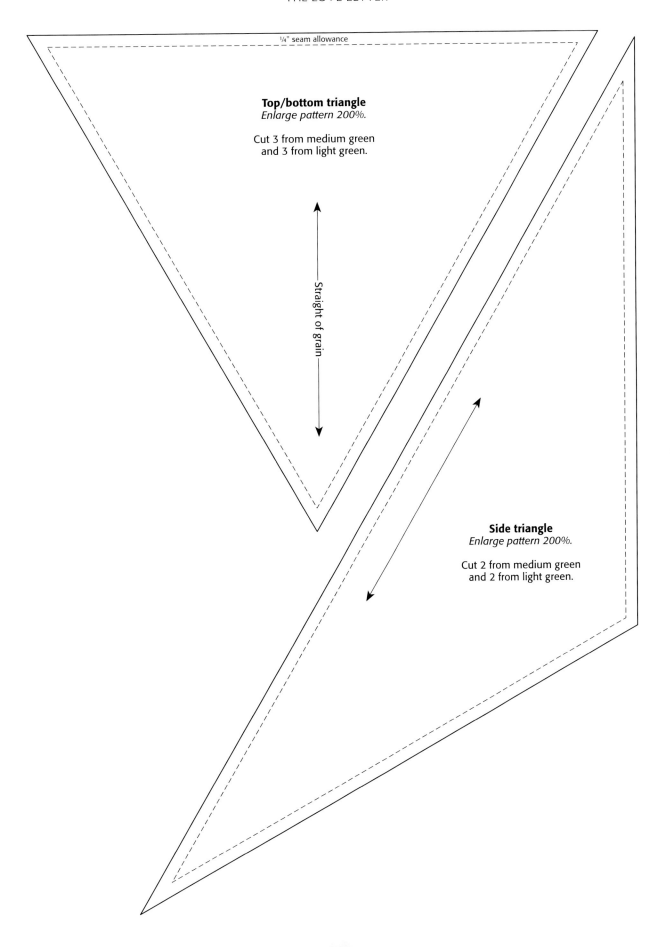

¼" seam allowance

Top/bottom triangle
Enlarge pattern 200%.

Cut 3 from medium green
and 3 from light green.

Straight of grain

Side triangle
Enlarge pattern 200%.

Cut 2 from medium green
and 2 from light green.

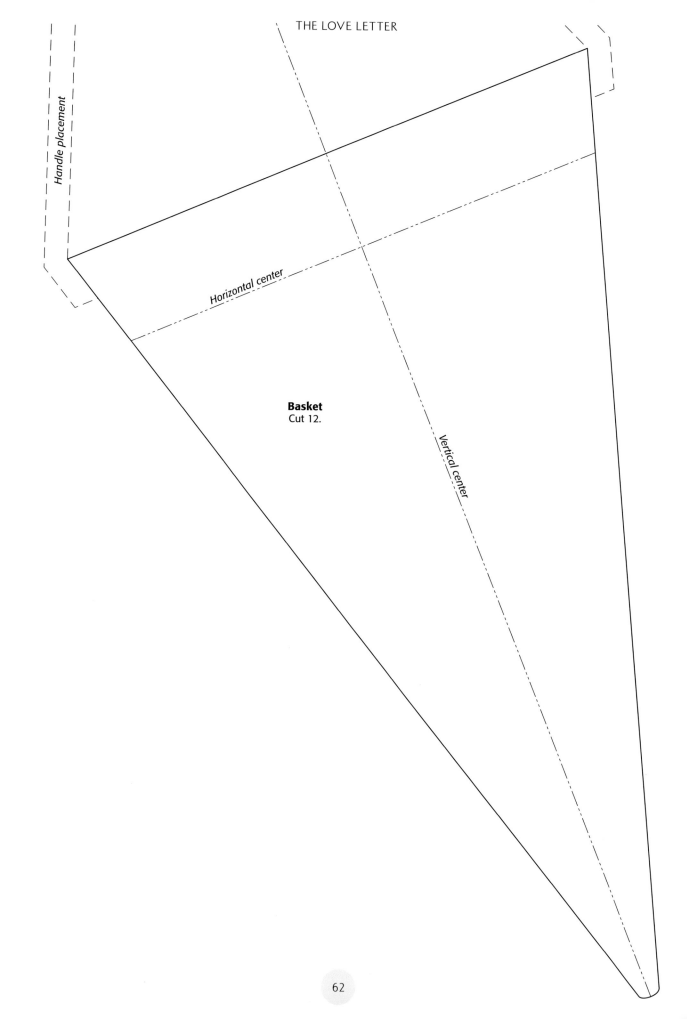

Handle placement

Horizontal center

Vertical center

Basket
Cut 12.

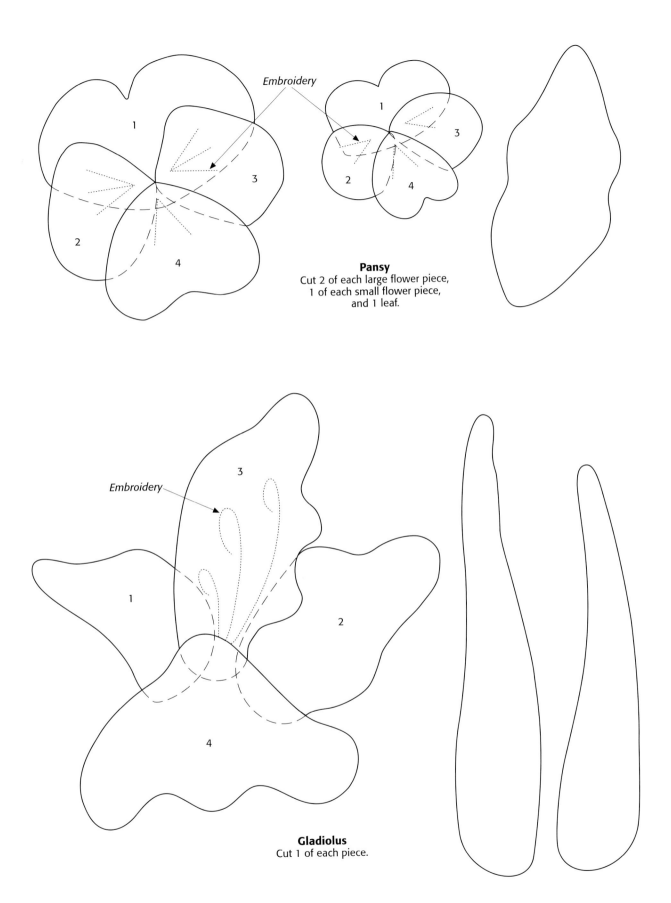

Embroidery

Pansy
Cut 2 of each large flower piece,
1 of each small flower piece,
and 1 leaf.

Embroidery

Gladiolus
Cut 1 of each piece.

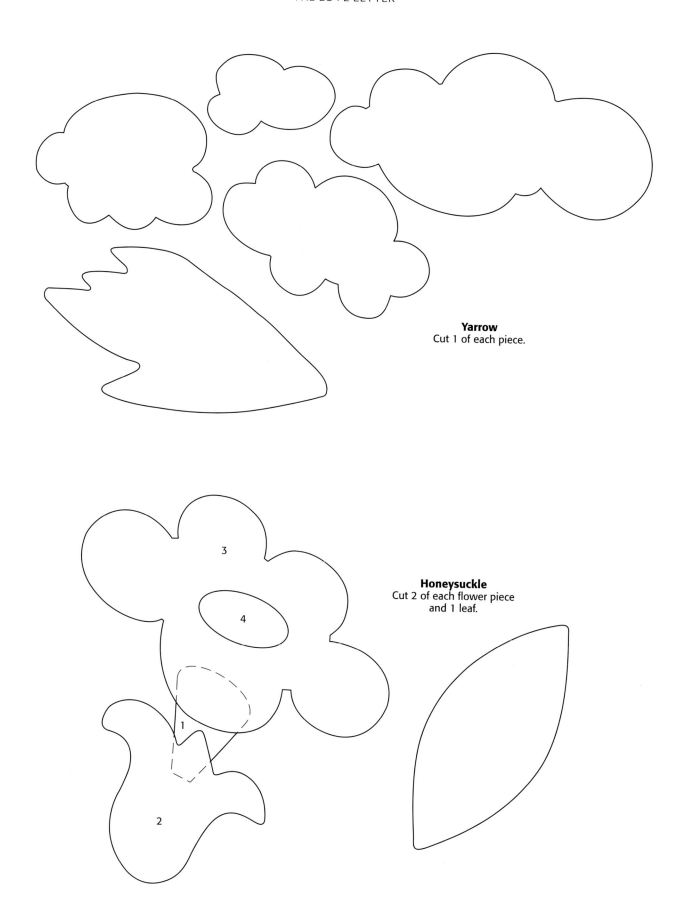

Yarrow
Cut 1 of each piece.

Honeysuckle
Cut 2 of each flower piece
and 1 leaf.

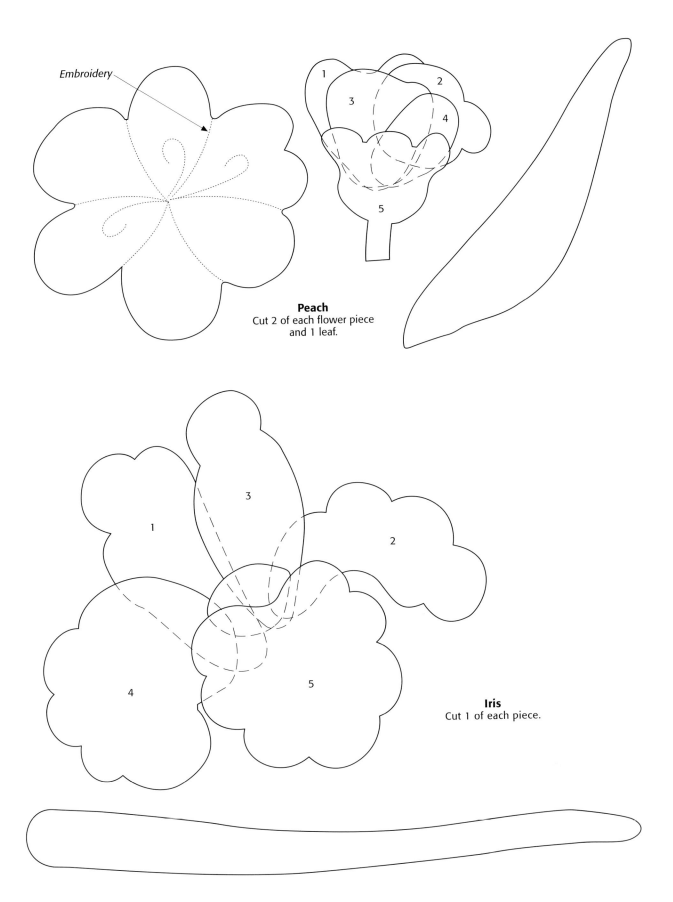

Embroidery

Peach
Cut 2 of each flower piece
and 1 leaf.

Iris
Cut 1 of each piece.

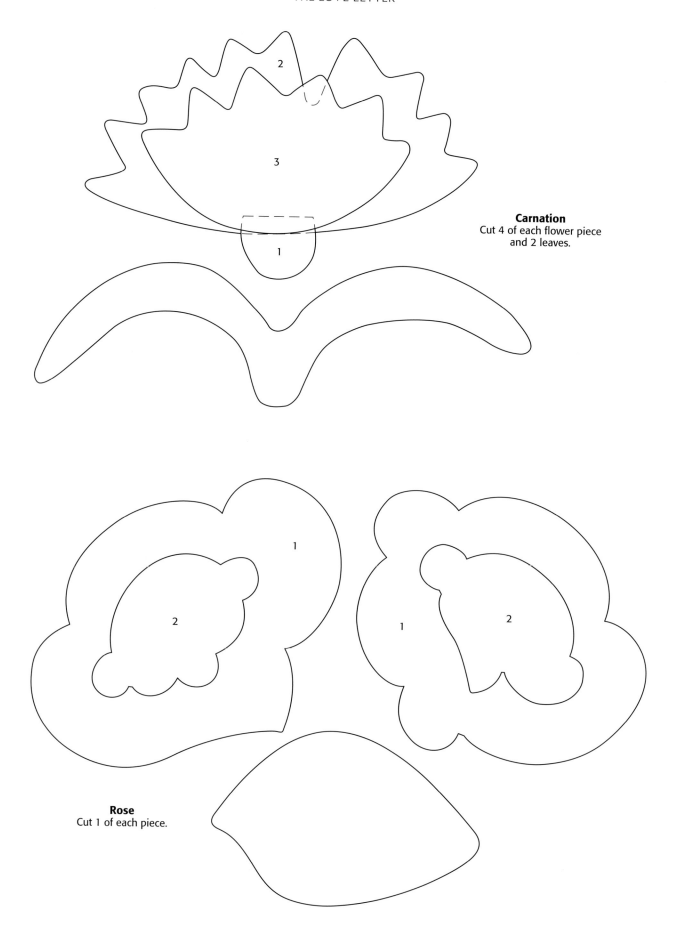

Carnation
Cut 4 of each flower piece
and 2 leaves.

Rose
Cut 1 of each piece.

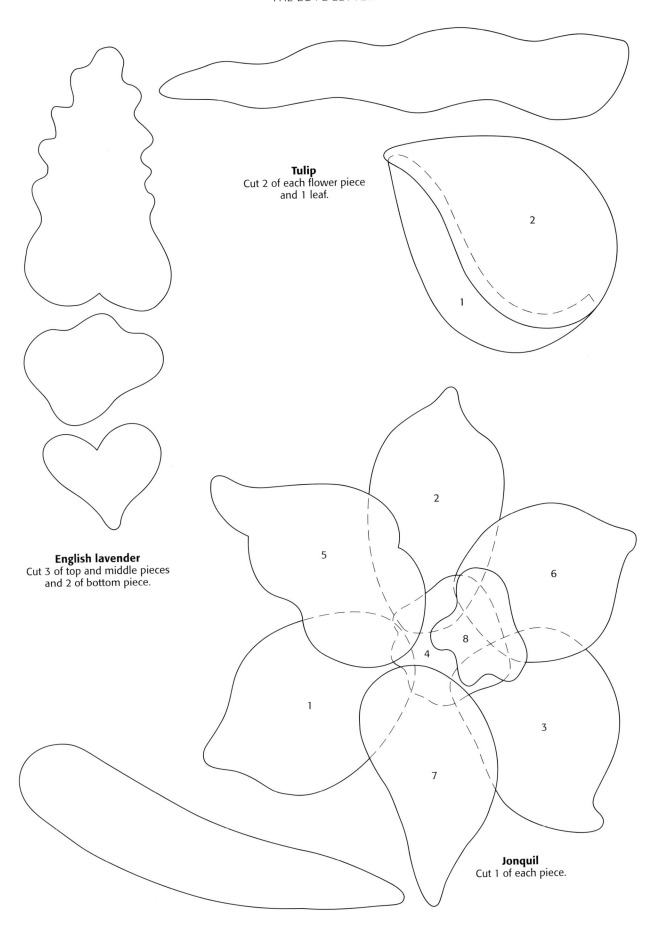

Tulip
Cut 2 of each flower piece
and 1 leaf.

English lavender
Cut 3 of top and middle pieces
and 2 of bottom piece.

Jonquil
Cut 1 of each piece.

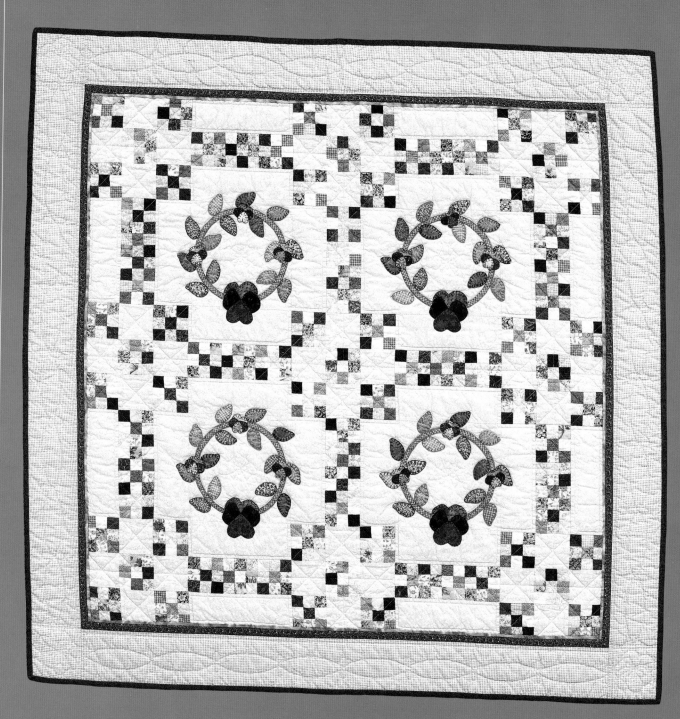

Finished Quilt: 54½" x 54½"

Finished Block: 9" x 9"

*The name "pansy" is actually a corruption of the French word "pensée,"
which means "thoughtfulness." This delightful little flower has had many charming
and curious names through the ages. It's been called "Cuddle-Me-To-You,"
"Tittle My Fancy," "Kiss Me at the Garden Gate," "Love in Idleness,"
and "Kiss Me Quick." At one time, it was believed that the pansy was the first flower
pierced by Cupid's arrow. If you dream of this flower, it means "contentment."*

Materials

Yardage is based on 42"-wide fabric.

1⅜ yards of tan fabric for background of appliqué blocks and pieced blocks

⅞ yard of light gray fabric for outer border

⅞ yard *total* of assorted dark fabrics for pieced blocks

⅔ yard *total* of assorted light fabrics for pieced blocks

⅝ yard *total* of assorted green fabrics for bias stems and leaves

¼ yard of light red fabric for inner border

¼ yard of pink fabric for folded flange border

¼ yard *total* of pink and red fabrics for flowers

½ yard of dark red fabric for binding

3½ yards of backing fabric

61" x 61" piece of batting

Template plastic

Paper-backed fusible web

½" bias press bar

¼" paper-backed fusible-web tape

Cutting

All strips are cut across the width of the fabric unless indicated otherwise.

From the tan fabric, cut:
4 squares, 9½" x 9½"

10 strips, 3½" x 42"; crosscut into:
 36 squares, 3½" x 3½"
 24 rectangles, 3½" x 9½"

From the assorted green fabrics, cut:
4 bias strips, 1½" x 27"

From the assorted dark fabrics, cut:
16 strips, 1½" x 42"

From the assorted light fabrics, cut:
14 strips, 1½" x 42"

From the pink fabric for folded flange border, cut:
5 strips, 1" x 42"

From the light red fabric, cut:
5 strips, 1" x 42"

From the light gray fabric, cut:
6 strips, 4½" x 42"

From the dark red fabric, cut:
6 strips, 2½" x 42"

Piecing the Blocks

1. For strip set A, sew a 1½" x 42" dark strip to each long side of a 1½" x 42" light strip. Press seams toward the dark strips. Make six. From these strip sets, cut 141 segments, 1½" wide.

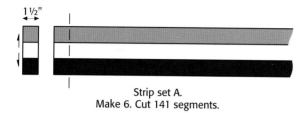

Strip set A.
Make 6. Cut 141 segments.

2. For strip set B, sew a 1½" light strip to each side of a 1½" dark strip. Press seams toward the dark strip. Make four. From these strip sets, cut 102 segments, 1½" wide.

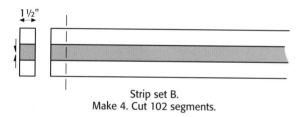

Strip set B.
Make 4. Cut 102 segments.

3. Sew one A segment to each side of a B segment to form a nine-patch unit. Make 60. In the same manner, sew a B segment to each side of an A unit. Make 21. Press the seams as indicated in the diagram.

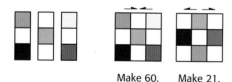

Make 60. Make 21.

4. Select two nine-patch units with dark corners and one unit with light corners. Sew them together as shown, being sure that seams butt together in opposite directions. Press. Sew a 3½" x 9½" tan rectangle to each side of the nine-patch unit to make a Nine Patch Stripe block. Press seams toward the rectangles. Make 12.

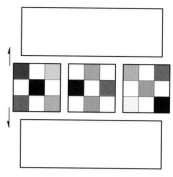

Nine Patch Stripe block.
Make 12.

5. Sew five nine-patch units and four 3½" tan squares together to make a Double Nine Patch block. Sew the blocks into rows and sew the rows together. Press seams toward the center row. Make nine.

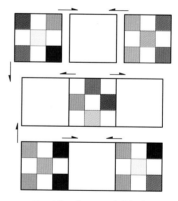

Double Nine Patch block.
Make 9.

Assembling the Quilt

1. Referring to the quilt assembly diagram on page 72, arrange the Double Nine Patch blocks, the Nine Patch Stripe blocks, and the plain 9½" tan squares.

2. Sew together into rows and press seams toward the plain squares.

3. Sew the rows together and press seams toward the plain squares.

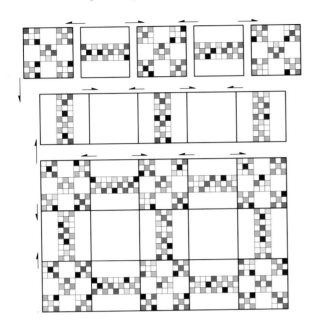

Appliquéing the Pansy Wreaths

Refer to "Appliqué" on page 9 as needed to complete the following steps.

1. Use the patterns on page 72 to prepare and label all the templates.

2. Use the templates and fusible web to prepare the flowers and leaves.

3. Use the 1½" green bias strips to make the stems for the wreaths.

4. Referring to the appliqué placement diagram, place the green bias stems around the plain tan squares to form the wreaths. Start at the bottom of each block so that the ends of the stems will be hidden under the large pansies. Appliqué the wreath in place using your preferred stitch.

5. Referring to the placement diagram, arrange all of the flowers and leaves around the wreath circle. Appliqué shapes in place using your preferred stitch.

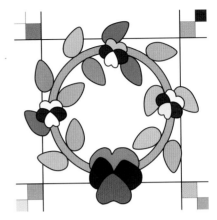

Appliqué placement

Adding the Borders

1. Sew the 1" pink strips together end to end and press. Fold the strip in half lengthwise with *wrong sides together* and press. Cut four 45½" pieces from the strip. With raw edges even, pin a strip to each side of the quilt, overlapping at the corners.

2. Sew the 1" light red strips together end to end and press. From this strip, cut two pieces 45½" long and two pieces 46½" long. Sew the 45½" strips to the top and bottom of the quilt and the 46½" strips to the sides of the quilt. The pink folded flange will be sandwiched between the red strips and the quilt top. Press all seams toward the red borders. Press the pink flange toward the quilt top.

Victorian Flower	Sentiment
Pansy	"You Occupy My Thoughts"

3. Sew the 4½" light gray strips together end to end and press. From this strip, cut two pieces 45½" long and two pieces 54½" long. Sew the 45½" strips to the top and bottom of the quilt and the 54½" strips to the sides of the quilt. Press all seams toward the borders.

Finishing the Quilt

Refer to "Finishing" on page 15 to layer, quilt, and bind your quilt.

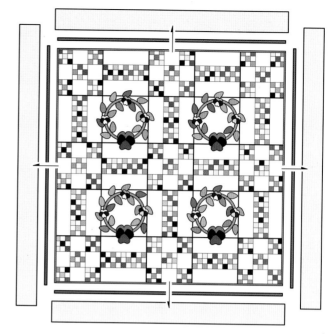

Quilt assembly

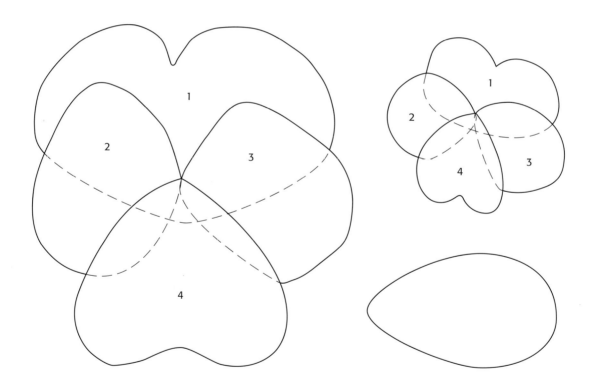

Pansy wreath
Cut 4 of each large flower piece,
12 of each small flower piece,
and 56 leaves.

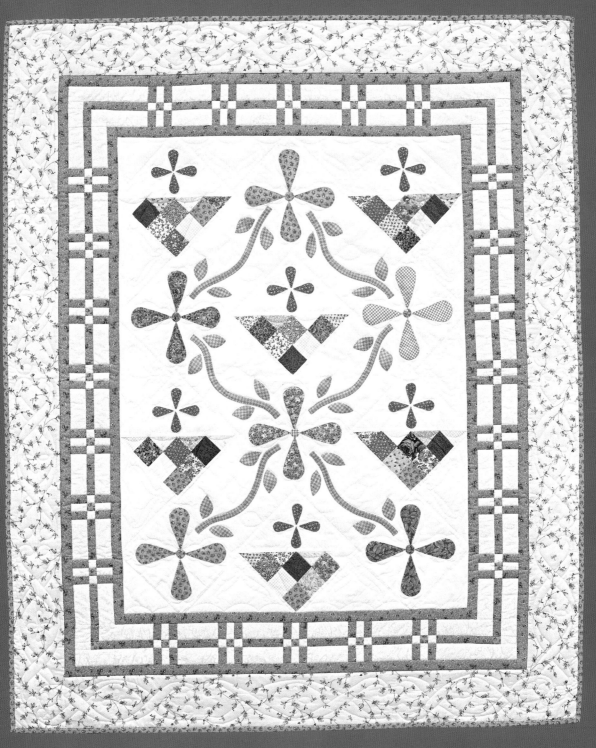

Finished Quilt: 54¾" x 65½"

Finished Block: 7½" x 7½"

The word "lilac" means "blue." A purple lilac was the color of mourning and in Victorian times, if you gave purple lilacs to a lover, you were actually hinting that your love had died. A related superstition portends that if a girl wears lilacs on her dress, she will be a spinster forever. Despite these ominous beliefs, the lilac was widely used in love potions.

Materials

Yardage is based on 42"-wide fabric.

2 yards of yellow print for outer border

1⅜ yards of white fabric for pieced blocks, alternate blocks, and setting triangles

1 yard *total* of assorted blue and purple fabrics for flowers and baskets

⅞ yard of green print for borders

⅞ yard of cream fabric for pieced border

⅔ yard of blue fabric for pieced border and binding

¼ yard of green check for stems and leaves

3½ yards of backing fabric

61" x 71" piece of batting

Template plastic

Sheet of No-Melt Mylar

Paper-backed fusible web

½" bias press bar

¼" paper-backed fusible-web tape

Cutting

All strips are cut across the width of the fabric unless indicated otherwise.

From the assorted blue and purple fabrics, cut:

36 squares, 2⅜" x 2⅜"

6 squares, 3⅛" x 3⅛"; cut twice diagonally to yield 24 triangles

From the white fabric, cut:

3 strips, 8" x 42"; crosscut into 12 squares, 8" x 8"

1 strip, 8⅜" x 42"; crosscut into 3 squares, 8⅜" x 8⅜". Cut each square once diagonally to yield 6 triangles. Use the remainder of the strip to cut 2 squares, 6¼" x 6¼". Cut each square in half diagonally to yield 4 triangles.

1 strip, 11⅞" x 42"; crosscut into 3 squares, 11⅞" x 11⅞". Cut each square twice diagonally to yield 12 triangles.

From the green check, cut:

80" of 1½"-wide bias strips

From the cream fabric, cut:

9 strips, 2" x 42"; crosscut 1 strip into:
 4 squares, 2" x 2"
 4 rectangles, 2" x 4¼"
 4 rectangles, 2¾" x 4"

5 strips, 1¼" x 42"

From the green print, cut:

11 strips, 1¼" x 42"; crosscut 1 strip into:
 8 rectangles, 1¼" x 2"

9 strips, 1½" x 42"

From the blue fabric, cut:

1 strip, 1¼" x 42"

4 squares, 1¼" x 1¼"

7 strips, 2½" x 42"

From the lengthwise grain of the yellow print, cut:

2 strips, 6" x 43¾"

2 strips, 6" x 65½"

Piecing the Basket Blocks

1. Arrange the 2⅜" blue and purple squares with the blue and purple triangles cut from 3⅛" squares. Sew into rows and press seams in alternating directions from row to row. Sew the rows together and press. Make six.

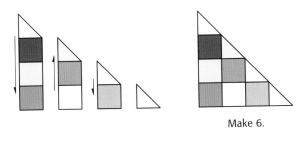

Make 6.

2. Sew an 8⅜" white triangle to a basket bottom unit from step 1. Press seams toward the white triangle. Make six.

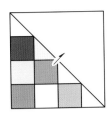

Make 6.

Appliquéing the Blocks

Refer to "Appliqué" on page 9 as needed to complete the following steps.

1. Use the patterns on page 77 to prepare and label all the templates.

2. Use the the templates and fusible web to prepare the flowers and leaves.

3. Use the 1½" green bias strips to make the stems.

4. Fold six of the 8" white squares in half in both directions and crease lightly to mark the centering lines. Position the large lilac blossoms with centers and fuse in place. Appliqué using your preferred stitch.

5. Position the small lilac blossoms on the top half of the Basket blocks. Fuse in place and appliqué using your preferred stitch.

Piecing the Conservatory Windows Border

The pieced border for this quilt is made of A and B units, plus four corner blocks. Note that some of the A units are cut slightly smaller than the bulk of the A units in order for the pieced border to fit neatly on the sides of the quilt.

1. Sew a 2" x 42" cream strip to each side of a 1¼" x 42" green print strip. Press seams toward the green strip. Make four. From the strip sets, cut 24 A units that are 4¼" wide and cut four A units that are 3⅝" wide.

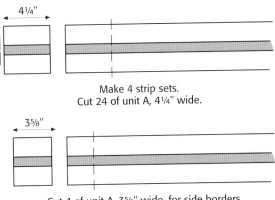

Make 4 strip sets.
Cut 24 of unit A, 4¼" wide.

Cut 4 of unit A, 3⅝" wide, for side borders.

2. Sew a 1¼" x 42" green print strip to each side of a 1¼" x 42" cream strip. Press seams toward the green strips. Make three. From the strip sets, cut 48 segments, each 2" wide.

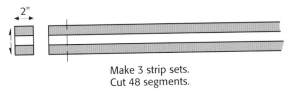

Make 3 strip sets.
Cut 48 segments.

Victorian Flower Sentiment

Lilac Blossoms "First Emotions of Love"

3. Sew a 1¼" x 42" cream strip to each side of the 1¼" x 42" blue strip. Press seams toward the blue strip. Cut the strip set into 24 segments, 1¼" wide.

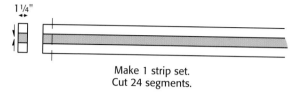

Make 1 strip set.
Cut 24 segments.

4. To make unit B, sew a segment from step 2 to each side of a segment from step 3. Press seams away from the center. Make 24.

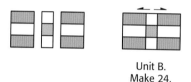

Unit B.
Make 24.

5. To make a corner block, sew a 2" cream square to a 1¼" x 2" green print rectangle. Press the seam toward the green rectangle. Sew a 1¼" blue square to a 1¼" x 2" green print rectangle. Press toward the green rectangle. Sew a 2" x 2¾" cream rectangle to the appropriate side of the pieced unit. Press toward the cream rectangle. Sew a 2" x 4¼" cream rectangle to the bottom of the pieced unit. Press toward the cream rectangle. Make four.

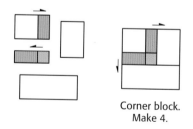

Corner block.
Make 4.

6. Sew six 4¼"-wide A units to five B units, beginning and ending with unit A. Press the seams toward unit B. Make two for the top and bottom of the quilt.

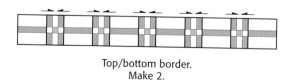

Top/bottom border.
Make 2.

7. Sew six 4¼"-wide A units to seven B units, beginning and ending with unit B. Then add a 3⅝"-wide unit A to each end of the border. Press all seams toward unit B. Sew a corner block to each end of the border, being careful to position the block correctly to complete the border pattern. Press seams toward unit A. Make two for the sides of the quilt.

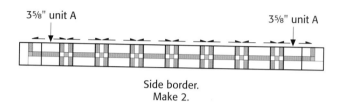

Side border.
Make 2.

Assembling the Quilt Center

1. Arrange the Basket blocks, Lilac Blossom blocks, and alternate blocks as shown. Add the 11⅞" side and 6¼" corner setting triangles.

2. Sew the blocks into diagonal rows, pressing seams toward the alternate blocks and setting triangles. Sew the rows together and press toward the alternate blocks and setting triangles.

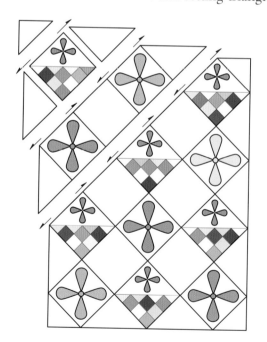

3. Trim the quilt to 32¼" x 43", taking care to trim ¼" away from the points where the blocks and setting triangles intersect.

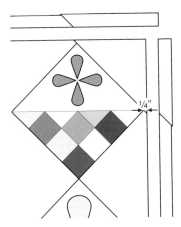

4. Referring to the photo on page 73 for placement, arrange the stems and leaves and fuse in place. Appliqué using your preferred stitch.

Adding the Borders

1. Sew the 1½" green print strips together end to end and press. From this strip, cut two pieces 32¼" long, two pieces 41¾" long, two pieces 45" long, and two pieces 54½" long.

2. Sew the 32¼" strips to the top and bottom of the quilt. Sew the 45" strips to the sides of the quilt. Press all seams toward the border.

3. Sew the top and bottom pieced borders to the quilt. Sew the side pieced borders to the quilt. Press all seams toward the green print border.

4. Sew a 41¾" green print strip to the top and bottom of the quilt. Sew a 54½" green print strip to each side of the quilt. Press all seams toward the green border.

5. Sew a 43¾" yellow print strip to the top and bottom of the quilt. Sew a 65½" yellow print strip to each side of the quilt. Press all seams toward the green border.

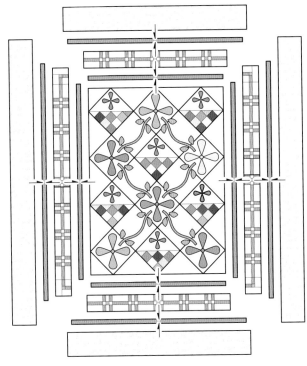

Quilt assembly

Finishing the Quilt

Refer to "Finishing" on page 15 to layer, quilt, and bind your quilt.

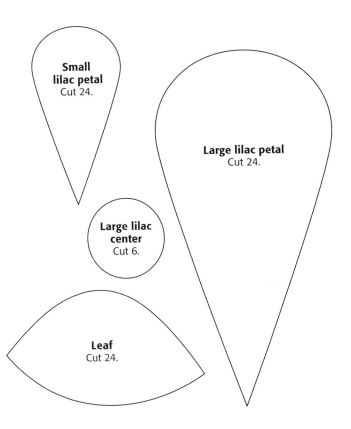

Small lilac petal Cut 24.

Large lilac petal Cut 24.

Large lilac center Cut 6.

Leaf Cut 24.

Beloved Daughter

Finished Quilt: 45½" x 45½"

Finished Secret Drawer Block: 4" x 4"

Finished Four Patch Block: 4" x 4"

Finished French China Border Block: 7" x 7"

There were many spin-offs from the Language of Flowers during the nineteenth century. One of them involved presentation. For example, if a flower was stripped of all leaves that meant there was nothing to hope for, because leaves were an emblem of hope. However, stripping the thorns from flowers meant that there was nothing to fear. Placing a marigold on top of your head showed mental anguish, while placing it on the breast showed indifference. To touch a flower to your lips was to say "Yes," and to pinch off a petal and throw it away was to say "No." Any ivy surrounding a bouquet signified "I desire," and "I have" was expressed by folding an ivy leaf.

Materials

Yardage is based on 42"-wide fabric.

1½ yards of tan fabric for background of pieced border

⅞ yard *total* of assorted red fabrics for border and Secret Drawer blocks

⅝ yard of tan-and-white stripe for background of Wicker Basket block

⅝ yard *total* of assorted soft pastels for Four Patch blocks, Secret Drawer blocks, and border

½ yard of light green fabric for Wicker Basket block

⅜ yard of light green print for Secret Drawer blocks and border

⅜ yard *total* of assorted dark green fabrics for stems, leaves, and Secret Drawer blocks

¼ yard *total* or scraps of assorted tan prints for Secret Drawer blocks

Scraps of red and gold fabrics for flowers

½ yard of red fabric for binding

3 yards of backing fabric

52" x 52" piece of batting

Template plastic

Sheet of No-Melt Mylar

Lightweight, nonwoven fusible interfacing

¼" and ⅜" bias press bars

¼" paper-backed fusible-web tape

Embroidery floss

Cutting

All strips are cut across the width of the fabric unless indicated otherwise.

From the tan-and-white stripe, cut:
1 rectangle, 17" x 21"

From the assorted tan prints, cut:
44 rectangles, 1½" x 2½"
44 squares, 1½" x 1½"

From the light green print, cut:
24 squares, 1½" x 1½" (Cut in sets of 8 matching squares for Secret Drawer blocks.)
24 squares, 1" x 1" (Cut in sets of 8 matching squares for Secret Drawer blocks.)
2 strips, 2" x 28½"
2 strips, 2" x 31½"

From the light green fabric for Wicker Basket block, cut:

30" of 1¼"-wide bias strips

From the assorted dark green fabrics, cut:

21" of 1¼"-wide bias strips

16 squares, 1½" x 1½" (Cut in sets of 8 matching squares for Secret Drawer blocks.)

16 squares, 1" x 1" (Cut in sets of 8 matching squares for Secret Drawer blocks.)

From the assorted pastels, cut:

55 squares, 2½" x 2½"

2 strips, 2½" x 28½"

From the assorted red fabrics, cut:

48 squares, 1½" x 1½" (Cut in sets of 8 matching squares for Secret Drawer blocks.)

48 squares, 1" x 1" (Cut in sets of 8 matching squares for Secret Drawer blocks.)

10 strips, 1½" x 42"

From the tan fabric for pieced border, cut:

8 strips, 1½" x 42"

2 strips, 2½" x 42"

2 strips, 3½" x 42"

3 strips, 7½" x 42"; crosscut into:
 28 rectangles, 1½" x 7½"
 16 rectangles, 2½" x 7½"
 4 squares, 7½" x 7½"

From the red binding fabric, cut:

5 strips, 2½" x 42"

Appliquéing the Wicker Basket Block

Refer to "Appliqué" on page 9 as needed to complete the following steps.

1. Use the patterns on pages 83–84 to prepare and label all the templates.

2. Use the templates and fusible interfacing to prepare the flowers, leaves, and basket.

3. Use the 1¼" dark green bias strips to make ¼" finished-width stems and the 1¼" light green bias strips to make the ⅜" finished-width basket handle.

4. Fold the 17" x 21" tan-and-white stripe rectangle in half in both directions and crease lightly to mark centering lines. Position the basket, handle, flowers, leaves, and stems. Fuse in place and appliqué using your preferred stitch.

5. Add French knots around the flower center. Trim the completed block to 16½" x 20½".

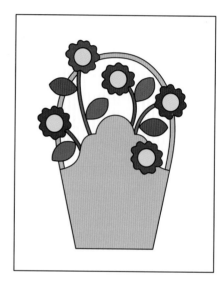

Appliqué placement for
Wicker Basket block

Piecing the Secret Drawer Blocks

1. Place a 1" light green, dark green, or red Secret Drawer square each corner of a 2½" pastel square with right sides together. Draw a diagonal line on the wrong side of the 1" square and sew on the line. Trim the seam allowance to ¼" and press toward the corner triangle. Repeat for the remaining corners using matching 1" squares. Repeat to make the number of units as shown.

Make 6. Make 3. Make 2.

2. Place a 1" red, light green, or dark green Secret Drawer square on one corner of a 1½" tan square with right sides together. Draw a diagonal line on the wrong side of the 1" square and sew on the line. Trim the seam allowance to ¼" and press toward the corner triangle. Repeat to make the number of each color as shown.

Make 24. Make 12. Make 8.

3. Make flying-geese units by placing a 1½" red, light green, or dark green Secret Drawer square on one end of a 1½" x 2½" tan rectangle, right sides together. Draw a diagonal line on the wrong side of the 1½" square and sew on the line. Trim the seam allowance to ¼" and press toward the corner triangle. Repeat for the other end of the rectangle using a matching 1½" square. Repeat to make the number of units as shown.

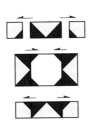

Make 24. Make 12. Make 8.

4. Using the units from steps 1 through 3, arrange a Secret Drawer block. Sew the units into rows and press seams in alternating directions from row to row. Sew the rows together and press. Make 11.

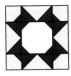 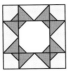 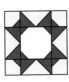

Make 6. Make 3. Make 2.

Piecing the Four Patch Blocks

Sew four 2½" pastel squares together into a Four Patch block as shown. Make 11.

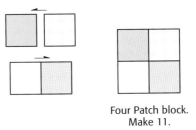

Four Patch block.
Make 11.

Piecing the French China Border

1. For strip sets A and B, sew 1½" x 42" tan and red strips together as shown. Press seams toward the red strips. Crosscut each strip set into 16 segments, 1½" wide.

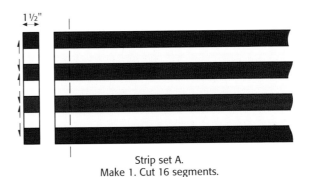

Strip set A.
Make 1. Cut 16 segments.

Strip set B.
Make 1. Cut 16 segments.

2. For strip set C, sew together two 2½" x 42" tan strips, two 1½" x 42" red strips, and one 1½" x 42" tan strip. Press seams toward the red strips. Crosscut into 16 segments, 1½" wide.

Strip set C.
Make 1. Cut 16 segments.

3. For strip set D, sew a 3½" x 42" tan strip to each side of a 1½" x 42" red strip. Press seams toward the red strip. Crosscut into 16 segments, 1½" wide.

Strip set D.
Make 1. Cut 16 segments.

4. Sew an A segment to a B segment, and then add a C segment. Sew a 1½" x 7½" tan rectangle to the bottom of the C segment. Add a D segment, and lastly add a 2½" x 7½" tan rectangle. Press as shown. Make 16.

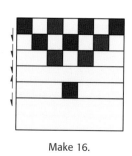

Make 16.

5. Draw a faint line from the center of the red square in the B segment to the center of the red square in the D segment. Embroider along that line with stem stitches.

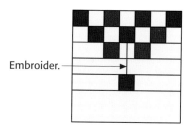

Embroider.

6. Sew four blocks together with a 1½" x 7½" tan rectangle between each block. Press seams toward the tan rectangles. Make four.

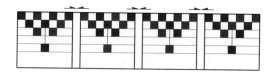

Make 4.

Assembling the Quilt Top

1. Sew the Secret Drawer blocks and Four Patch blocks together as shown for the top and bottom border sections. Press toward the Four Patch blocks. Make two.

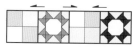

Make 2.

Victorian Flower Sentiment

Cinquefoil "Beloved Daughter"

2. Sew the Secret Drawer blocks and Four Patch blocks together as shown for the side border sections. Press toward the Four Patch blocks.

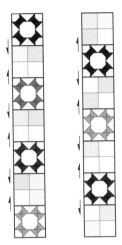

Left border Right border

3. Sew the top and bottom border sections to the quilt and press seams toward the quilt center. Sew the side border sections to the quilt and press seams toward the center. Sew a 2½" x 28½" pastel strip to the left and right sides of the quilt. Press seams toward the strips.

4. Sew a 2" x 28½" light green strip to the top and bottom of the quilt. Press seams toward the green border. Sew a 2" x 31½" light green strip to the sides of the quilt. Press seams toward the green border.

5. Sew a French China border to the top and bottom of the quilt. Press seams toward the green border. Sew a 7½" tan square to both ends of the remaining French China borders and press seams toward the squares. Sew a border to each side of the quilt. Press seams toward the green border.

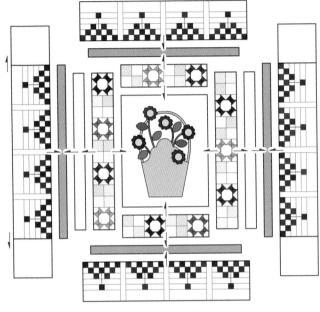

Quilt assembly

Finishing the Quilt

Refer to "Finishing" on pages 15 to layer, quilt, and bind your quilt.

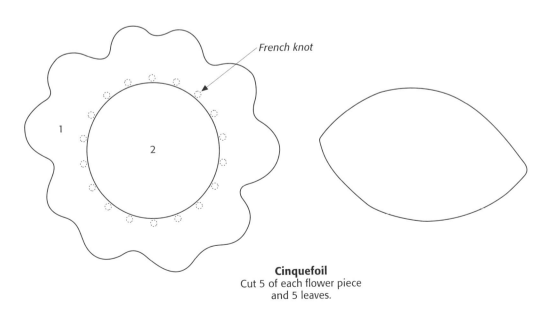

French knot

1

2

Cinquefoil
Cut 5 of each flower piece
and 5 leaves.

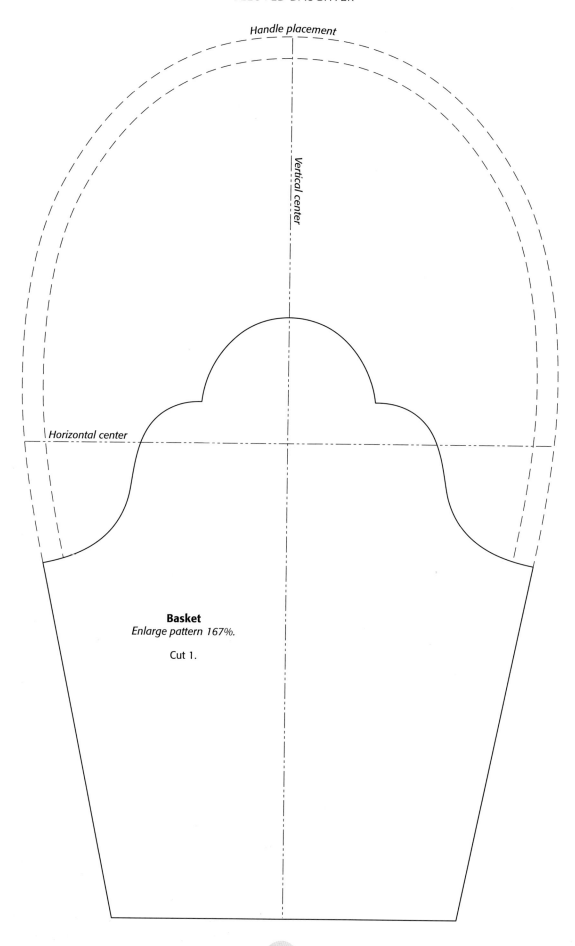

Handle placement

Vertical center

Horizontal center

Basket
Enlarge pattern 167%.

Cut 1.

The Gathering

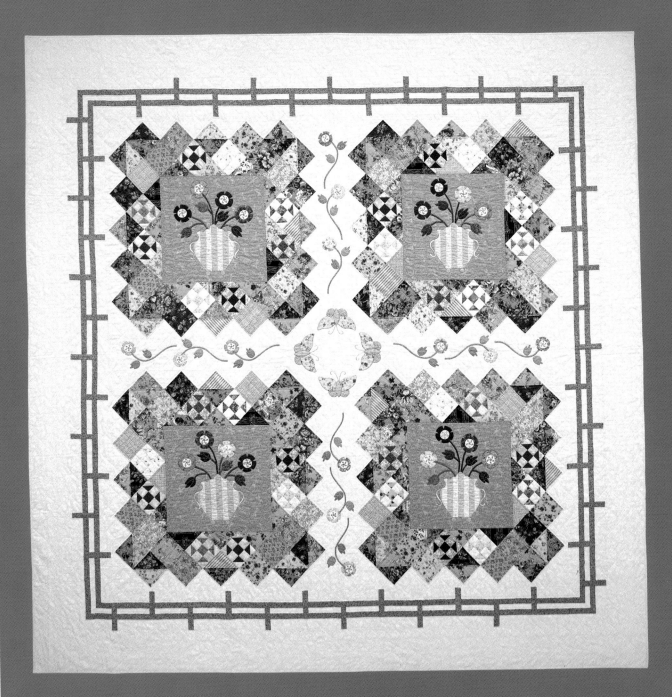

Finished Quilt: 112½" x 112½"

Finished Block: 38¼" x 38¼"

Finished Chinese Ladder Border Unit: 7" x 7"

The Shoofly plant bears an amazing resemblance to the Shoofly quilt block. It's believed that the flower's meaning was derived from the gatherings at quilting bees and possibly the flies (and people) around the Pennsylvania Dutch dessert, Shoofly pie.

Materials

Yardage is based on 42"-wide fabric.

9 yards of white background fabric for blocks, sashing, borders, and binding

3 yards *total* of assorted florals for blocks

1⅓ yards of sage green fabric for Shoofly Flower blocks

1⅜ yards of blue fabric for Chinese Ladder border

1 yard of stripe fabric for urn and handle

1 yard of green fabric for leaves and stems

⅝ yard *total* of assorted medium and dark fabrics for Shoofly blocks

½ yard *total* of assorted fabrics for flowers and butterflies

10 yards of backing fabric

120" x 120" piece of batting

Template plastic

Sheet of No-Melt Mylar

Lightweight, nonwoven fusible interfacing

⅜" bias press bar

¼" paper-backed fusible-web tape

Embroidery floss

Cutting

All strips are cut across the width of the fabric unless indicated otherwise.

From the sage green fabric, cut:
4 squares, 20" x 20"

From the stripe fabric, cut:
57" of 1¼"-wide bias strips

From the green fabric, cut:
305" of 1¼"-wide bias strips

From the white background fabric, cut:
5 strips, 2⅜" x 42"; crosscut into 64 squares, 2⅜" x 2⅜"

7 strips, 2" x 42"; crosscut into 128 squares, 2" x 2"

4 strips, 7⅝" x 42"; crosscut into 16 squares, 7⅝" x 7⅝". Cut each square twice diagonally to yield 64 triangles.

2 strips, 7¼" x 42"; crosscut into 8 squares, 7¼" x 7¼". Cut each square once diagonally to yield 16 triangles.

4 strips, 6½" x 38¾"

24 strips, 2½" x 42" (12 strips are for binding)

10 strips, 1½ x 42"

9 strips, 1¼ x 42"

From the remaining length of the white background fabric, cut:
2 strips, 7½" x 98½"

2 strips, 7½" x 112½"

From the remaining width of the white background fabric, cut:

1 square, 6½" x 6½"

48 rectangles, 2½" x 7½"

From the assorted medium and dark fabrics, cut the following pieces into matching sets, each containing one 2" square and two 2⅜" squares:

32 squares, 2" x 2"

64 squares, 2⅜" x 2⅜"

From the assorted florals, cut:

7 strips, 5⅜" x 5⅜"; crosscut into 48 squares, 5⅜" x 5⅜"

8 strips, 5" x 42"; crosscut into 64 squares, 5" x 5"

3 strips, 7⅝" x 42"; crosscut into 12 squares, 7⅝" x 7⅝". Cut each square twice diagonally to make 48 triangles.

From the blue fabric, cut:

20 strips, 1½" x 42"

7 strips, 1½" x 42"; crosscut into 48 rectangles, 1½" x 5½"

Appliquéing the Shoofly Flower Blocks

Refer to "Appliqué" on page 9 as needed to complete the following steps.

1. Use the patterns on pages 91–93 to prepare and label all the templates.

2. Use the templates and fusible interfacing to prepare the flowers, leaves, urns, urn feet, and butterflies.

3. Use the 1¼" stripe bias strips to make the handles on the urns. Use the 1¼" green bias strips to make the stems.

4. Fold each 20" sage green square in half in both directions and crease lightly to mark centering lines. Position the urn, urn feet, handles, flowers, and stems. Fuse in place and appliqué using your preferred stitch.

5. Embroider the details on the flowers and leaves. Trim the completed blocks to 19⅝" square.

Appliqué placement

Piecing the Shoofly Blocks

1. To make one Shoofly block, place a 2⅜" medium or dark square with a 2⅜" background square, right sides together. Draw a line diagonally on the wrong side of the background square. Sew ¼" from both sides of the line. Cut on the line and press seams toward the medium or dark triangles. Make four half-square-triangle units.

Make 4 for each block.

2. Arrange four half-square-triangle units with four 2" background squares and one matching 2" medium or dark square as shown. Sew units into rows, pressing seams toward the background squares. Sew the rows together and press toward the middle row. Make 32 blocks.

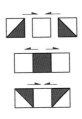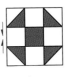

Make 32.

Piecing the Half-Square-Triangle Blocks

Place two 5⅜" floral squares right sides together and draw a diagonal line on the wrong side of one of the squares. Sew ¼" from both sides of the line. Cut on the line and press seams toward one of the triangles. Repeat to make 48 half-square-triangle blocks.

Make 48.

Completing the Large Blocks

1. Arrange two Shoofly blocks, three 7⅝" floral triangles, and one half-square-triangle block as shown. Sew together and press seams away from the Shoofly blocks. Make 16 small triangle sections.

Make 16.

2. Arrange one 7¼" white triangle, four 7⅝" white triangles, two half-square-triangle blocks, and four 5" floral squares as shown above right. Sew together and press as shown. Make 16 large triangle sections.

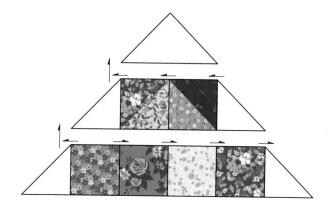

3. Sew a small triangle section to each side of the Shoofly Flower block. Press seams toward the block. Sew a large triangle section to each side of the block and press seams toward the large triangle sections. Make four.

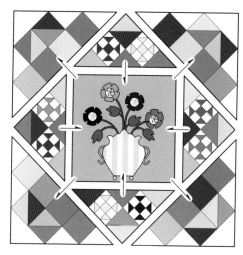

Make 4.

Appliquéing the Sashing Panels

1. Fold each 6½" x 38¾" white rectangle in half lengthwise and crease lightly to mark the centering line.

2. Arrange the flowers, stems, and leaves. Fuse in place and appliqué using your preferred stitch. Make four.

Make 3.

Make 1.

Sashing appliqué placement

Assembling the Quilt Center

1. Sew two large blocks and a sashing panel together as shown. Press seams toward the sashing. Make two.

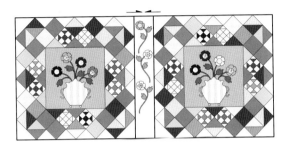

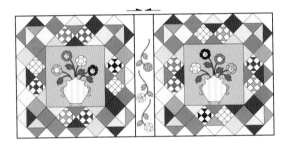

2. Sew a sashing panel to opposite sides of a 6½" background square. Press seams toward the sashing.

3. Sew the sections together and press seams toward the sashing.

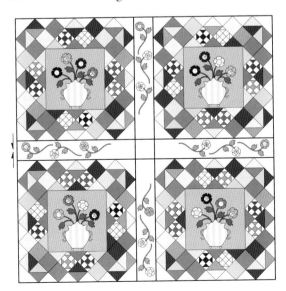

4. Position and appliqué one butterfly on each sashing panel, following the placement guide for the butterfly appliqué.

Appliqué placement for butterflies

Piecing the Chinese Ladder Border

1. Sew two 1½" x 42" blue strips, one 1½" x 42" background strip, and one 2½" x 42" background strip together as shown. Make 10. Press the seams of eight strip sets toward the blue strips; set the other strip sets aside. Crosscut each of these eight sets into 6½"-wide segments. Make 48.

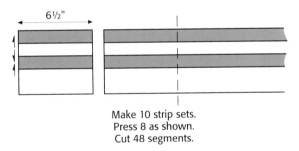

Make 10 strip sets.
Press 8 as shown.
Cut 48 segments.

2. For unit A, divide the stack of segments in half so that one stack has a blue strip on the top. Sew a 1½" x 5½" blue rectangle to the right side and press the seam toward the rectangle. Sew a 2½" x 7½" background rectangle to the top of the unit and press toward the rectangle. Make 24.

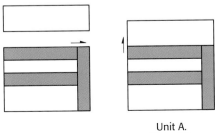

Unit A.
Make 24.

3. For unit B, make sure that the white strip is on the top and sew a 1½" x 5½" blue rectangle to the right side. Press the seam toward the blue rectangle. Sew a 2½" x 7½" background rectangle to the bottom of the unit and press toward the rectangle. Make 24.

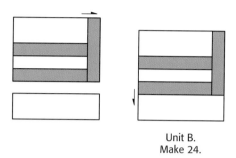

Unit B.
Make 24.

4. Use the two remaining strip sets for the corner units. First, sew a 2½" x 42" white strip to the blue edge of each strip set. Then press the seams of one set toward the blue strips, and press the seams of the other set toward the white strips. Cut each set into four 7½" segments.

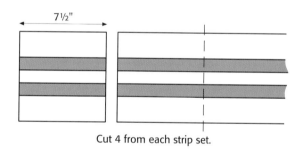

7½"

Cut 4 from each strip set.

5. Place a segment from each strip set with right sides together. Draw a diagonal line in the direction shown. Sew on the line and trim the seam allowance to ¼". Press the seam open. Make four corner units.

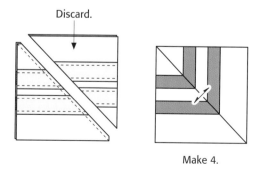

Discard.

Make 4.

6. Sew six A units alternately with six B units in the order shown. Press seams in one direction. Make four.

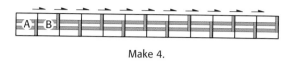

A B

Make 4.

7. Sew a corner unit to two of the borders and press toward the corner units. Make two.

Make 2.

Assembling the Quilt

1. Sew the 1¼" background strips together end to end and press. From this strip cut two pieces 83" long and two pieces 84½" long. Sew the 83" strips to the top and bottom of the quilt. Sew the 84½" strips to the sides of the quilt. Press all seams toward the strips.

2. Sew a shorter Chinese Ladder border to the top and bottom of the quilt and press seams toward the background strips. Sew a longer Chinese Ladder border to each side of the quilt and press seams toward the background strips.

Victorian Flower Sentiment

Shoofly "Hearth, Home, or Gathering"

3. Sew the 98½" background strips to the top and bottom of the quilt. Sew the 112½" background strips to the sides of the quilt. Press all seams toward the background strips.

Finishing the Quilt

Refer to "Finishing" on pages 15 to layer, quilt, and bind your quilt.

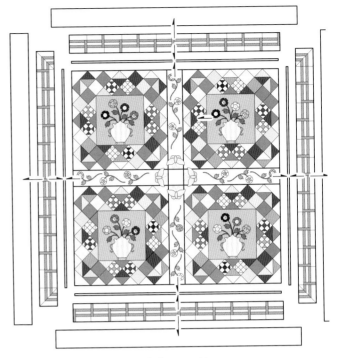

Quilt assembly

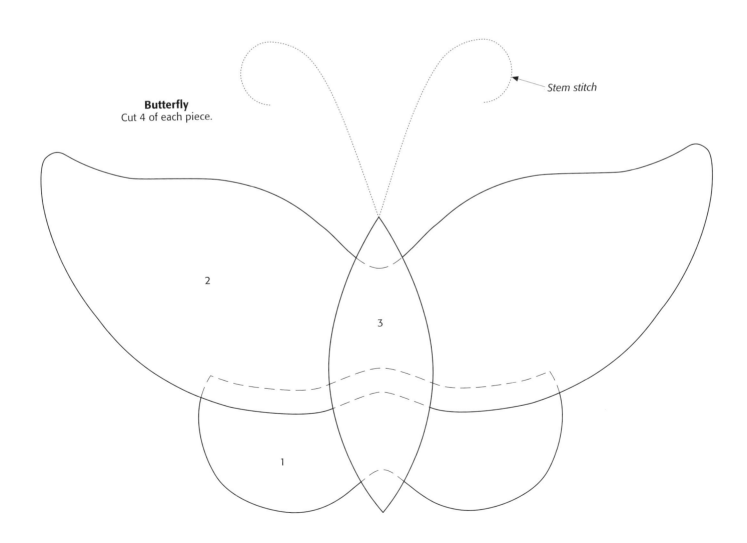

Stem stitch

Butterfly
Cut 4 of each piece.

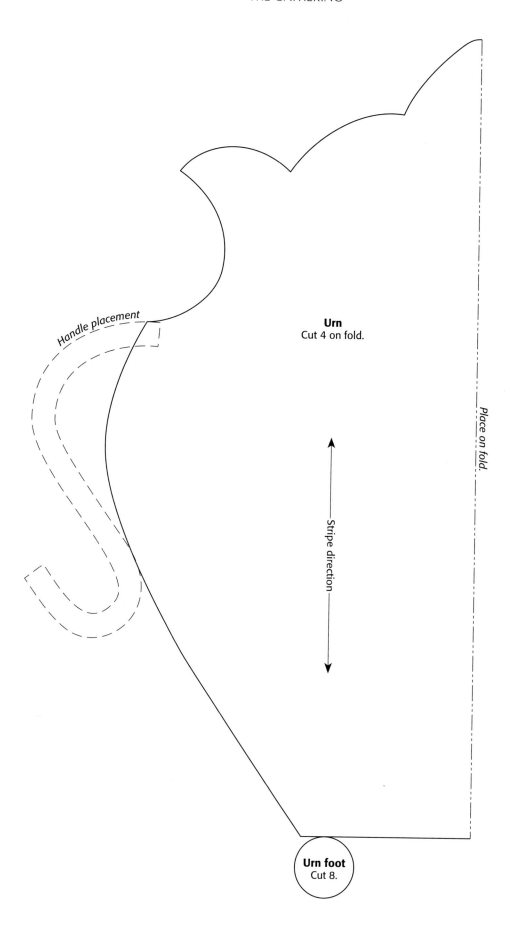

Handle placement

Urn
Cut 4 on fold.

Stripe direction

Place on fold.

Urn foot
Cut 8.

Stem stitch

Shoofly Flower block
Cut 16 of each flower piece
and 16 leaves.

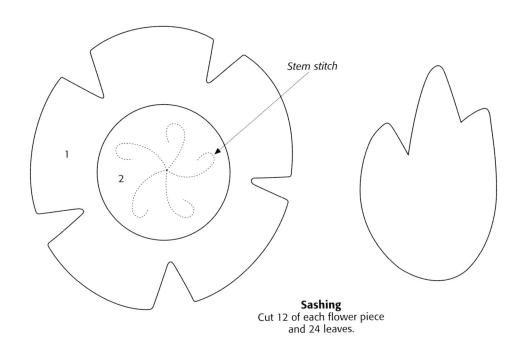

Stem stitch

Sashing
Cut 12 of each flower piece
and 24 leaves.

Virtues

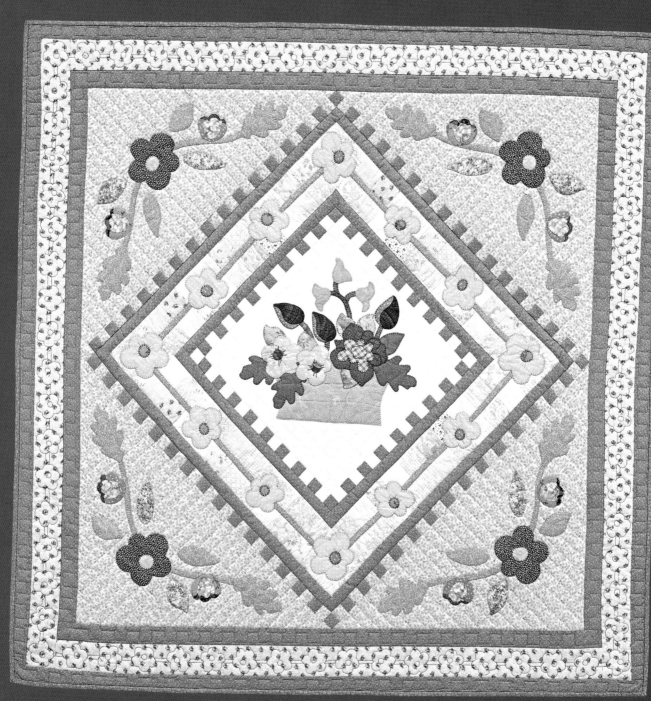

Finished Quilt: 56¾" x 56¾"

During the reign of Queen Victoria, she and her husband, Prince Albert, held dear the virtues of hard work, family, and religion, because they felt these ideas brought strength to industrial-age England. The bright and cheerful appliqués of this quilt extol some of those virtues. The oak leaves symbolize strength, the purple anemones represent faith, and the yellow buttercups indicate cheerfulness.

Of course, long ago people believed that anyone who smelled the buttercup would go insane but that wearing it around the neck during the waning of the moon would reverse the condition!

Materials

Yardage is based on 42"-wide fabric.

1¾ yards of dark tan fabric for borders and binding

1⅔ yards of medium tan fabric for border and setting triangles

1 yard *total* of assorted green fabrics for leaves and stems

¾ yard of white fabric for background of Center Medallion block and dentil border

¾ yard of medium light fabric for outer light border

⅝ yard *total* of assorted light fabrics for buttercup border

½ yard *total* of assorted gold fabrics for flowers

¼ yard *total* of assorted purple fabrics for flowers

¼ yard medium tan fabric for basket

3½ yards of backing fabric

63" x 63" piece of batting

Template plastic

Sheet of No-Melt Mylar

Lightweight, nonwoven fusible interfacing

½" bias press bar

¼" paper-backed fusible-web tape

Embroidery floss

Cutting

All strips are cut across the width of the fabric unless indicated otherwise.

From the white fabric, cut:
1 square, 18" x 18"
3 strips, 1½" x 42"

From the assorted light fabrics, cut:
96 squares, 2½" x 2½"

From the medium light fabric, cut:
6 strips, 3" x 42"

From the dark tan fabric, cut:
12 strips, 1½" x 42"; from 2 of the strips, cut 2 pieces, 1½" x 18½", and 2 pieces, 1½" x 20½"
11 strips, 2" x 42"
6 strips, 2½" x 42"

From the medium tan fabric, cut:
4 strips, 1½" x 42"

2 squares, 23½" x 23½"; cut once diagonally to yield 4 triangles

From the assorted green fabrics, cut:
112" of 1½"-wide bias strips

Appliquéing the Center Medallion Block and Corner Swags

Refer to "Appliqué" on page 9 as needed to complete the following steps.

1. Use the patterns on pages 99–101 to prepare and label all the templates.

2. Use the templates and fusible interfacing to prepare the flowers, leaves, and basket.

3. Use the 1½" green bias strips to make the stems.

4. Fold the 18" white square in half in both directions and crease lightly to mark centering lines. Position the shapes and fuse in place. Appliqué using your preferred machine stitch.

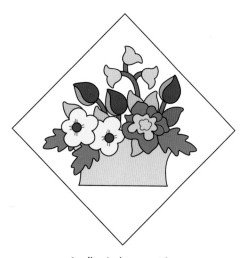

Appliqué placement for
Center Medallion block

5. Fold the four 24" tan triangles in half and crease lightly to mark centering lines. Position the shapes and fuse in place. Appliqué using your preferred machine stitch.

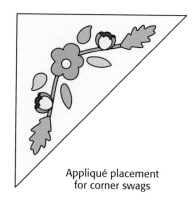

Appliqué placement
for corner swags

6. Embroider details on the mock orange blossoms and buttercups.

7. Trim the Center Medallion block to 16½" after all the appliqué and embroidery is complete.

Piecing the Inner Dentil Border

1. Sew three 1½" x 42" white strips alternately with three 1½" x 42" dark tan strips. Press seams toward the dark tan strips. Make one. Cut 12 segments, 1½"-wide, from the strip set.

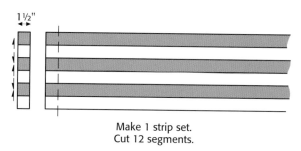

Make 1 strip set.
Cut 12 segments.

2. Sew three segments together end to end, maintaining the pattern. Press seams toward the tan pieces. Remove the last two pieces (one white and one tan) from the row. Make two.

Make 2.

3. Repeat step 2, but don't remove any pieces. Make two.

Make 2.

4. Sew the borders from step 2 to the top and bottom of the Center Medallion block. Sew the borders from step 3 to the sides of the Center Medallion block. Press all seams toward the border.

5. Sew a 1½" x 18½" dark tan strip to the top and bottom of the quilt. Sew a 1½" x 20½" dark tan strip to each side of the quilt. Press all seams toward the tan strips.

Making the String of Buttercups Border

1. Sew ten 2½" light squares together in a row and press seams to one side. Repeat for another row and press seams to the opposite side. Join the rows and press. Make two.

Make 2.

2. Repeat step 1 using 14 squares in each row.

Make 2.

3. Sew a border from step 1 to the top and bottom of the center medallion. Press seams toward the dark tan strip. Sew a border from step 2 to the sides of the medallion center and press seams toward the dark tan strip.

4. On top of this border arrange four large buttercup flowers, one in each corner, and place one small and one medium buttercup along each side. Use the seam allowance of the borders to position the stems. Appliqué the stems using your preferred machine stitch.

5. Sew three 1½" x 42" dark tan strips together end to end and press. From this strip, cut two pieces 28½" long and two pieces 30½" long. Sew the 28½" strips to the top and bottom of the quilt. Sew the 30½" strips to the sides of the quilt. Press all seams toward the tan strips.

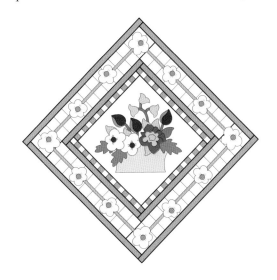

Victorian Flower	Sentiment
Buttercup	"Cheerfulness"
Coral Bells	"Hard Work"
Japanese Anemone	"Faith"
Mock Orange	"Brotherly Love"
Oak	"Strength"
Tulips	"Charity"

Piecing the Outer Dentil Border

1. Sew four 1½" x 42" dark tan strips alternately with four 1½" x 42" medium tan strips. Press seams toward the dark tan strips. Cut into 1½"-wide segments. Make 16.

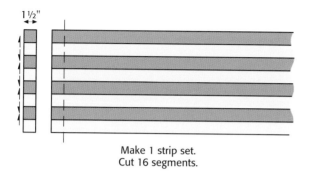

1½"

Make 1 strip set.
Cut 16 segments.

2. Sew four segments together end to end, maintaining the pattern. Press toward the tan pieces. Remove the last two pieces (one white and one tan) from the border. Make two.

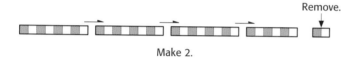

Remove.

Make 2.

3. Repeat step 2, but don't remove any pieces. Make two.

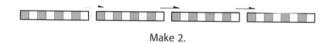

Make 2.

4. Sew a border from step 2 to the top and bottom of the quilt. Sew a border from step 3 to the sides of the quilt. Press all seams toward the dark tan strips.

Assembling the Quilt

1. Sew an appliquéd corner triangle to each side of the quilt center so that it forms a "square in a square."

2. Sew five 2" x 42" dark tan strips end to end and press. From this strip, cut two pieces 45¾" long and two pieces 48¾" long. Sew the 45¾" strips to the top and bottom of the quilt. Sew the 48¾" strips to the sides of the quilt. Press all seams toward the strips.

3. Sew six 3" x 42" medium-light strips end to end and press. From this strip cut two pieces 48¾" long and two pieces 53¾" long. Sew the 48¾" strips to the top and bottom of the quilt. Sew the 53¾" strips to the sides of the quilt. Press all seams toward the dark tan strips.

4. Sew six 2" x 42" dark tan strips end to end and press. From this strip, cut two pieces 53¾" long and two pieces 56¾" long. Sew the 53¾" strips to the top and bottom of the quilt. Sew the 56¾" strips to the sides of the quilt. Press all seams toward the dark tan strips.

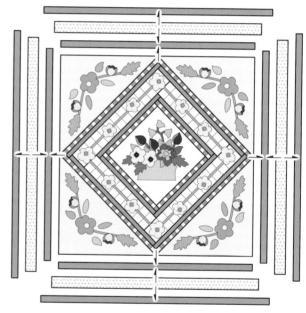

Quilt assembly

Finishing the Quilt

Refer to "Finishing" on pages 15 to layer, quilt, and bind your quilt.

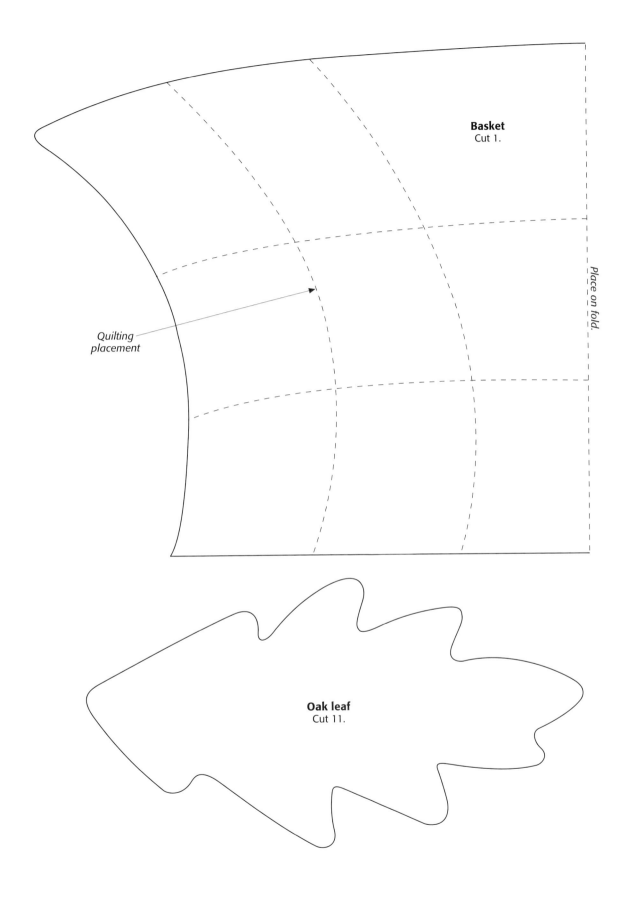

Basket
Cut 1.

Place on fold.

Quilting placement

Oak leaf
Cut 11.

Stem stitch

Small buttercup
Cut 8 of each piece for
the String of Buttercups border.

Medium buttercup
Cut 6 of each piece.
Place 2 in Bread Basket
and 1 in each corner of
the String of Buttercups border.

Large buttercup
Cut 4 of each piece
for the corner swags.

Leaf
Cut 14.

Coral bell
Cut 3.

1

2

Tulip
Cut 3 of each piece.

1

Stem stitch

2

Leaf
Cut 8.

Mock orange
Cut 1 of each piece.

2

1

3

Japanese anemone
Cut 8 of each piece.

Are You Still Mine?

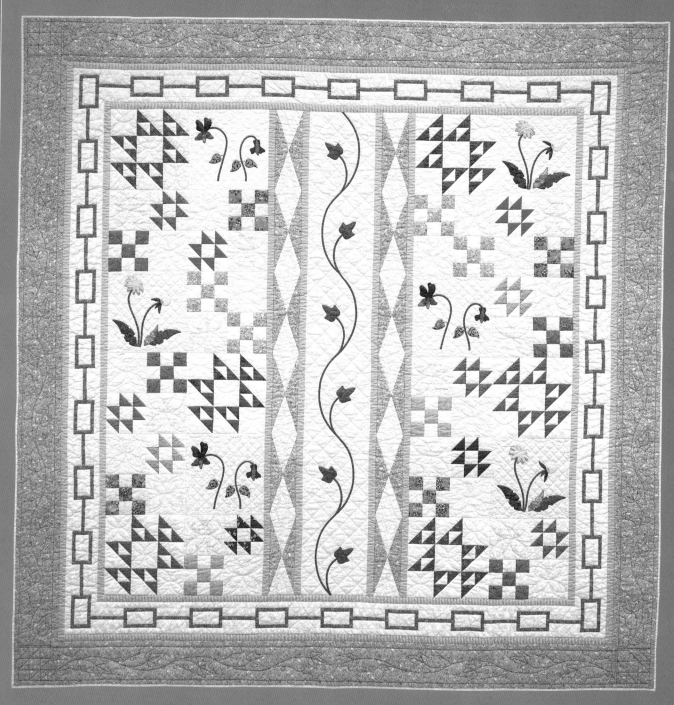

Finished Quilt: 97" x 99"

Finished Large Block: 12" x 12"

Finished Diamond Sashing Block: 4" x 12"

Finished Love Chain Border Block: 3" x 5"

The dandelion belongs to a collection called "The Dial of Flowers." These plants served as timepieces because they opened and closed their flower heads at the same time every day. As amusement, many gardens were planted so that if you stood in the center, you could rotate around the garden as hands of a clock, observing the time. The dandelion closed at eight or nine o'clock each night.

Materials

Yardage is based on 42"-wide fabric.

5⅝ yards of cream fabric for blocks, sashing, borders, and binding

3½ yards of lavender fabric for blocks and border

2⅛ yards *total* of assorted cream fabrics for blocks, sashings, and borders

1⅛ yards *total* of assorted dark fabrics for blocks

1⅛ yards of gold fabric for sashing and borders

1 yard of green fabric for blocks, leaves, and stems

½ yard of violet fabric for pieced border

½ yard *total* of assorted fabrics for flowers

9 yards of backing fabric

103" x 105" piece of batting

Template plastic

Paper-backed fusible web

¼" bias press bar

¼" paper-backed fusible-web tape

Embroidery floss

Cutting

All strips are cut across the width of the fabric unless indicated otherwise.

From the lengthwise grain of the 5⅝-yard piece of cream fabric, cut;
1 strip, 10½" x 72½"
3 squares, 12½" x 12½"
6 binding strips, 2½" x 72½"

From the remaining width of this cream fabric, cut:
24 squares, 6½" x 6½"
10 strips, 1¾" x 42"
4 strips, 6½" x 42"
17 strips, 1½" x 42"
4 strips, 2½" x 42"

From the assorted cream fabrics, cut:
3 squares, 12½" x 12½"

From the green fabric, cut:
183" of 1"-wide bias strips

From the lavender fabric, cut:
5 strips, 2½" x 42"

From the lengthwise grain of the remaining lavender fabric, cut:

2 strips, 6¾" x 84½"

2 strips, 6¾" x 99"

From the violet fabric, cut:

14 strips, 1" x 42"; crosscut 6 of the strips into 64 rectangles, 1" x 3½"

From the gold fabric, cut:

24 strips, 1½" x 42"

For *each* of the 6 Wandering Lover blocks, cut:

From the assorted cream fabrics:

3 squares, 4½" x 4½"

3 squares, 4⅞" x 4⅞"; crosscut once diagonally to yield 6 triangles

3 squares, 2⅞" x 2⅞"

From the assorted dark fabrics:

9 squares, 2⅞" x 2⅞"; crosscut 6 squares once diagonally to yield 12 triangles

For *each* of the 10 Old Maid's Puzzle blocks, cut:

From the assorted cream fabrics:

3 squares, 2½" x 2½"

3 squares, 2⅞" x 2⅞"

From the assorted dark fabrics:

3 squares, 2⅞" x 2⅞"

For *each* of the 7 Nine Patch blocks, cut:

From the assorted cream fabrics:

4 squares, 2½" x 2½"

From the assorted dark fabrics:

5 squares, 2½" x 2½"

Appliquéing the Floral Blocks and Ivy Sashing

Refer to "Appliqué" on page 9 as needed to complete the following steps.

1. Use the patterns on pages 109–110 to prepare and label all the templates.

2. Use the templates and fusible web to prepare the flowers and leaves.

3. Use the 1" green bias strips to make the stems.

4. Fold the 12½" cream squares in half in both directions and crease lightly to mark the centering lines. Position the shapes and fuse in place. Appliqué using your preferred machine stitch.

5. Stitch a gold French knot in the center of each left flower in the Violet blocks.

Appliqué placement for Violet block. Make 3.

Appliqué placement for Dandelion block. Make 3.

6. Fold the 10½" x 72½" cream strip in half lengthwise. Along the length of the strip, make a small mark within the seam allowance every 12" to indicate the repeat. Flip the ivy panel placement template to mirror the image every 12" until the entire panel has been marked.

7. Position the stems and ivy leaves and fuse in place. Appliqué using your preferred machine stitch.

Piecing the Wandering Lover Blocks

1. Place a 2⅞" cream square with a 2⅞" dark square, right sides together. Draw a diagonal line on the wrong side of the cream square. Sew ¼" from both sides of

Appliqué placement for ivy panel

the line. Cut on the line and press seams toward the dark triangles. Make six.

Mark diagonal. Stitch ¼" from line. Cut along line. Press. Make 6.

2. Sew a 2⅞" dark triangle to adjacent sides of each half-square-triangle unit from step 1 as shown. Press seams toward the triangles. Make six.

 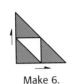

Make 6.

3. Sew a 4⅞" cream triangle to the opposite side of each pieced triangle unit from step 2. Press seams toward the cream triangle. Make six.

Make 6.

4. Referring to the block diagram, arrange pieced units with 4½" cream squares. Sew the units and squares into rows and press the seams in alternating directions from row to row. Sew the rows together and press. Repeat to make six blocks.

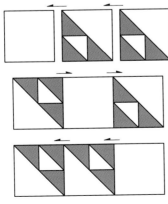

Make 6.

Piecing the Old Maid's Puzzle Blocks

1. Place a 2⅞" cream square with a 2⅞" dark square, right sides together. Draw a line diagonally on the wrong side of the cream square. Sew ¼" from both sides of the line. Cut on the line and press toward the dark triangles. Make six.

Mark diagonal. Stitch ¼" from line. Cut along line. Press. Make 6.

2. Referring to the block diagram, arrange the pieced units and 2½" cream squares. Sew the units and squares into rows and press seams in alternating directions from row to row. Sew the rows together and press. Repeat to make 10 blocks.

 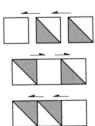

Make 10.

Piecing the Nine Patch Blocks

Referring to the block diagram, arrange five 2½" dark squares with four 2½" cream squares. Sew the squares into rows and press seams toward the dark squares. Sew the rows together and press. Repeat to make 14 blocks.

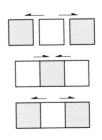

Make 14.

Plain or "Poetry" Blocks

You can leave these 6½" x 6½" blocks plain; however, there are a few special poems that the Victorians associated with flowers, and I printed them on the blocks. If you like, you can print poems directly on treated fabric using your computer printer. Or, you can stabilize your fabric squares by ironing freezer paper on the wrong side and write the poems onto the squares using a permanent-ink pen.

Piecing the Diamond Sashing Blocks

1. Use the triangle A template to trace triangles across the 6½"-wide cream strips as shown. Cut 24 A triangles.

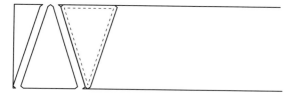

Cut 24.

2. Use the triangle B template to trace triangles across the 2½"-wide lavender strips as shown. Cut 24 B triangles.

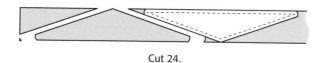

Cut 24.

3. Follow the piecing diagram to sew one A triangle to one B triangle. This is a half-diamond. Be sure to block the seam to give it more stability when you join the halves to complete a diamond. Press seams toward the B triangles. Repeat to make 12 half-diamonds.

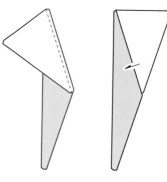

Make 12.

4. Make a small mark ¼" in on the seam of each half-diamond where both halves will meet in the center. Match the mark on each half and pin.

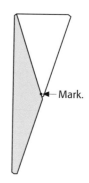

◄— Mark.

5. Sew the two halves together and press. The unit should now measure 4½" x 12½". Make 12 blocks.

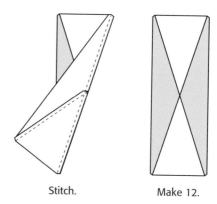

Stitch. Make 12.

6. Sew six of the blocks together end to end and press. Repeat.

Make 2.

Piecing the Love Chain Border

1. To make unit A, sew a 1" x 42" violet strip to both sides of a 2½" x 42" cream strip. Press seams toward the violet strips. Make four. Cut each strip set into 32 segments, 4½" wide.

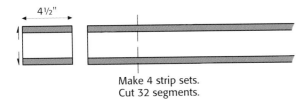

4½"

Make 4 strip sets.
Cut 32 segments.

2. Sew a 1" x 3½" violet rectangle to each end of a strip-set segment. Make 32.

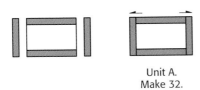

Unit A.
Make 32.

3. To make unit B, sew a 1¾" cream strip to both sides of a 1" violet strip. Press seams toward the violet strip. Make five. For the top and bottom borders, cut 16 B1 segments that are 5⅜" wide. For the side borders, cut 16 B2 segments that are 5⅛" wide.

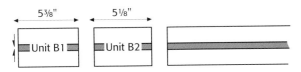

5⅜" 5⅛"

Unit B1 Unit B2

Make 5 strip sets.
Cut 16 units, 5⅜" wide, for top/bottom borders
and 16 units, 5⅛" wide, for side borders.

4. Make the top and bottom borders using seven A units and eight 5⅜"-wide B1 units. Press seams toward unit A.

5. Make the side borders using nine A units and eight 5⅛"-wide B2 units. Press seams toward unit BA2.

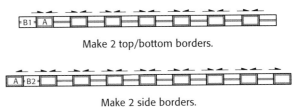

B1 A

Make 2 top/bottom borders.

A B2

Make 2 side borders.

Assembling the Quilt

1. Arrange the appliqué and pieced blocks for each side of the quilt top. Sew the small blocks together into rows, and then sew the rows together. Sew the blocks together and press.

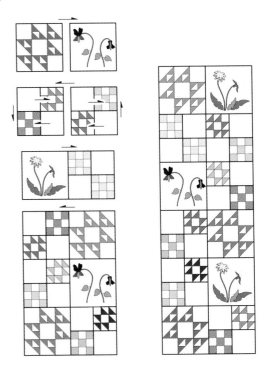

2. Sew the 1½" x 42" gold strips together end to end and press. From this strip cut four pieces 72½" long, two pieces 70½" long, two pieces 74½" long, two pieces 82½" long, and two pieces 86½" long.

3. Sew a 72½" gold strip to each side of each Diamond Sashing strip and press seams toward the gold strips.

4. Sew the panels together and press to complete the interior of the quilt top.

5. Sew a 70½" gold strip to the top and bottom of the quilt. Sew a 74½" gold strip to each side of the quilt. Press all seams toward the gold strips.

6. Sew the 1½" x 42" cream strips together end to end *in pairs* to make 8 long strips. Press. Trim four of the strips as follows: two pieces 72½" long and two pieces 76½". Cut the remaining 1½" x 42" cream strip into quarters. Sew one of these short pieces to each remaining long cream strip end to end and press. Trim these strips as follows: two strips 80½" long and two strips 84½" long.

7. Sew the 72½" strips to the top and bottom of the quilt and the 76½" strips to the sides of the quilt. Press all seams toward the gold border.

8. Sew the top and bottom sections of the Love Chain border to the quilt and press seams toward the cream strips. Sew the side sections of the Love Chain border to the quilt and press seams toward the cream strips.

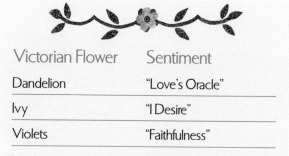

Victorian Flower	Sentiment
Dandelion	"Love's Oracle"
Ivy	"I Desire"
Violets	"Faithfulness"

Victorians believed that if you wanted to know whether you were still loved, you could just blow on the seed head of a dandelion. If even one seed remained, you could feel reassured.

9. Sew the 80½" cream strips to the top and bottom of the quilt. Sew the 84½" cream strips to the sides of the quilt. Press all seams toward the cream strips.

10. Sew the 82½" gold strips to the top and bottom of the quilt. Sew the 86½" gold strips to the sides of the quilt. Press all seams toward the gold strips.

11. Sew the 83½" lavender strips to the top and bottom of the quilt. Sew the 99" lavender strips to the sides of the quilt. Press all seams toward the lavender strips.

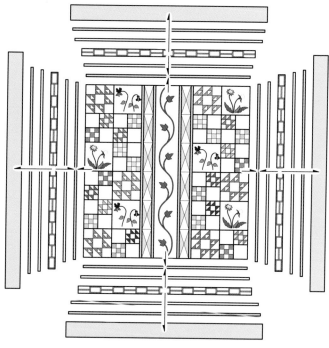

Quilt assembly

Finishing the Quilt

Refer to "Finishing" on pages 15 to layer, quilt, and bind your quilt.

French knot

Violet
Cut 3 of each flower piece
and 9 leaves.

Ivy leaf
Cut 6.

Embroidery

Dandelion
Cut 3 of each flower piece, 3 small leaves,
and 3 and 3 reversed large leaves.

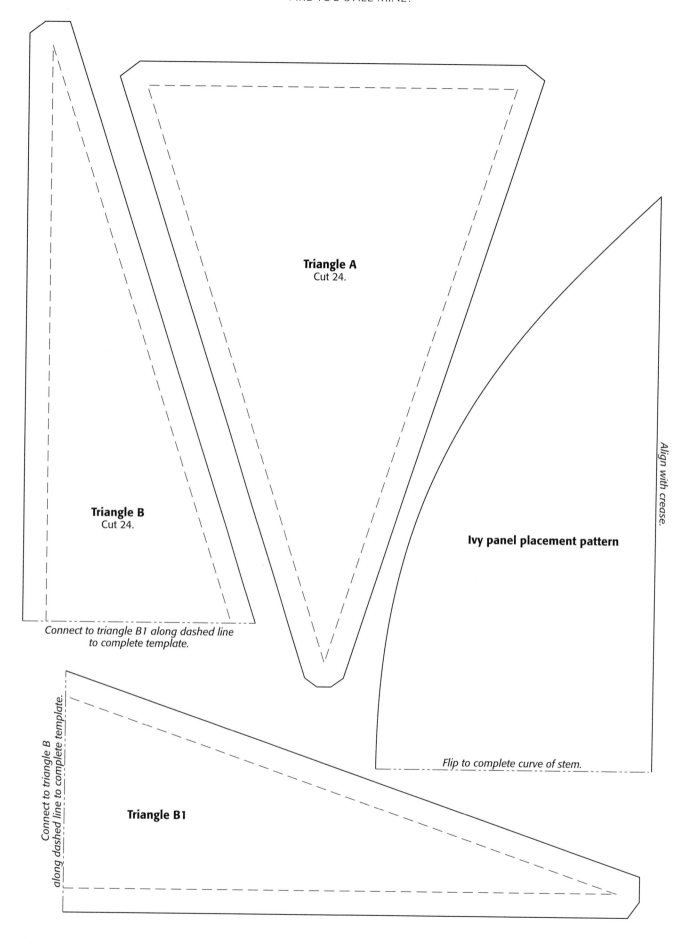

Triangle A
Cut 24.

Triangle B
Cut 24.

Connect to triangle B1 along dashed line to complete template.

Ivy panel placement pattern

Align with crease.

Flip to complete curve of stem.

Connect to triangle B along dashed line to complete template.

Triangle B1

Bibliography

Author unknown. *The Bouquet of Flowers.* Benjamin B. Mussey, 1846.

Author unknown. *The Illustrated Language and Poetry of Flowers.* London: George Routledge and Sons, 1884.

Author unknown. *The Language and Poetry of Flowers and Poetic Handbook of Wedding Anniversary Pieces, Album Verses and Valentines Together with A Great Number of Beautiful Poetical Quotations from Famous Authors.* Hearst and Co., 1897.

Bruce, Evangeline. *Napoleon and Josephine: An Improbable Marriage.* New York: Kensington Publishing Corp., 1995.

Connell, Charles. *Aphrodisiacs in Your Garden.* Taplinger Publishing Co., 1966.

Cook, Alice Brown. *Early American Herb Recipes.* Japan: Bonanza Books, 1966.

DK Books. *The Herb Society of America's New Encyclopedia of Herbs and Their Uses.* Dorling Kindersley, 1995.

Dumont, Henrietta. *The Floral Offering; A Token of Affection and Esteem; Comprising The Language and Poetry of Flowers.* H. C. Peck and Theo. Bliss, 1858.

Edgarton, Miss S. C. *The Flower Vase; Containing The Language of Flowers and Their Poetic Sentiments.* Lowell, Powers and Baily, 1844.

Fowler, Professor O. S. *Creative and Sexual Science on Manhood, Womanhood and Their Mutual Interrelations; Love, its laws, power, etc.: Selection or Mutual Adaptations: Courtship, Married Life and Perfect Children; their generation, Endowment, paternity, maternity, bearing, nursing and rearing, together with Puberty, boyhood, girlhood, etc., sexual impairments restored, male vigor and Female health and beauty perpetuated and augmented, etc., as taught by Phrenology and Physiology.* New York: Fowler and Wells, 1875.

Garland, Sarah. *The Complete Book of Herbs and Spices.* Viking Press, 1979.

Gifford, Edward S. *The Charms of Love.* London: Faber and Faber, 1962.

Hatton, Richard G. *The Handbook of Plant and Floral Ornament from Early Herbals.* Dover Publications, 1960.

Lipsett, Linda Otto. *To Love and To Cherish.* San Francisco: The Quilt Digest Press, 1989.

Maple, Eric. *The Secret Lore of Plants and Flowers.* London: Robert Hale Ltd., 1980.

Markrich, Lilo, and Edgar Kiewe. *Victorian Fancywork: Nineteenth Century Needlework Patterns and Designs.* Chicago: Henry Regnery Co., 1974.

Phillips, Roger, and Martyn Rix. *The Random House Book on Perennials Vol. 1 and 2.* Random House, 1991.

Rogers, Barbara. *The Encyclopedia of Everlastings.* New York: Weidenfeld and Nicolson, 1988.

Swerdlow, Joel L. *Nature's Medicine: Plants that Heal.* National Geographic, 2000.

Time-Life Books. *The Time-Life Encyclopedia of Gardening.* Time-Life Books, 1977.

Waterman, Catharine. *Flora's Lexicon: An Interpretation of The Language and Sentiment of Flowers with an Outline of Botany and a Poetical Introduction.* Sampson and Co., 1857.

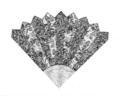

About the Author

Janna Sheppard was born and raised in the nation's Sweetheart City, Loveland, Colorado. She graduated from the University of Northern Colorado with a Bachelor of Arts degree in Vocational Home Economics and taught home economics classes in Nevada from 1989 to 1997. After retirement she moved back home to Loveland and now enjoys quilting full-time.

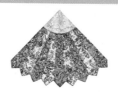